Douglas Hall

KLEE

PHAIDON

The author and publishers would like to thank all those museum authorities and private owners who have kindly allowed works in their possession to be reproduced. The pictures are © by Spadem, Paris, and Cosmopress, Geneva, 1977.

Phaidon Press Limited, Littlegate House, St Ebbe's Street, Oxford
Published in the United States of America by E. P. Dutton, New York

First published 1977

© 1977 by Phaidon Press Limited

ISBN 0 7148 1803 8
Library of Congress Catalog Card Number: 77–80140

Printed in Great Britain by Waterlow (Dunstable) Limited

KLEE

Few painters have filled in their own artistic birth certificates with such emphasis and clarity as Paul Klee. He did so in Kairouan in Tunisia, on 16 April 1914. On that day Klee entered in his diary: 'Colour possesses me . . . That is the meaning of this happy hour: colour and I are one. I am a painter.'

Klee was then already thirty-four. He was born on 18 December 1879 near Bern in Switzerland, the son of Hans Klee, a teacher of music, German by birth and nationality. Paul's mother, like her husband, had been trained as a musician. As a boy Klee learned to play the violin to near-professional standard. Later, after his marriage in 1906 to the pianist Lily Stumpf, musical evenings were a regular part of his family life. In establishing the freedom of the visual arts to act independently of representation, the analogy with music was very important and Klee was well qualified to understand both the use of this analogy and its limitations.

Klee's appearance was unusual. Will Grohmann, who knew him well, refers to his exotic appearance, with yellowish skin like an Arab's, high domed forehead, large brown eyes, and a deliberate gravity, which expressed itself in sparing words. Photographs bear out Grohmann's recollections. Klee's diaries, which he kept from 1898 to 1918, are evidence that he lived his imaginative life at a high level of intensity, the entries sometimes bordering on an unforced surrealism, though often mixed with sharp observation and acid comment.

As well as his training in music, Klee received a thorough academic education. One thing that remained with him from school was a knowledge of Greek, which he continued to read throughout life. As well as possessing a knowledge of Greek and of French classics, he was aware of the advances of contemporary French and German art, literature and music.

Klee graduated from the *Literarschule* in Bern in 1898. Through his later schooldays he had hesitated between music and art as a career, but by that time his mind was made up. Now came the decision that all ambitious young provincial artists had to make: where to study art? He chose Munich. In 1940, shortly before his death, Klee put the reasons for his decision simply: 'The realization of my aim at that time – and the same would be true in part today – led me abroad. I had to choose between Paris and Germany, and my feeling for Germany was the stronger. That is how I came to go to the Bavarian capital.'

{Munich, then, it was. If Klee had chosen Paris the development of his art and even of modern art in general would surely have been different. The English-language version of the history of modern art has given Paris the undisputed leadership. But with hindsight we can see that to go to Munich, in 1898, was not inappropriate. The Symbolist current was flowing strongly in Europe, not only in Paris. The arrival of Symbolism caused the march of French pictorial logic to falter, allowing a number of artists of genius, from outside France, to arrive on the international scene with profound effect on the history of art.}

Werner Haftmann suggests that the German spirit of idealism asserts itself 'whenever Western man longs for clarification of the inner worlds, for images that rise to the surface from the innermost depths'. The end of the nineteenth century was such a time, and for

such underlying reasons Klee's attachment to Germany was historically fortunate. It was not initially, or in the main, German-born artists who assisted this imagery to the surface, but men from the periphery, like the Norwegian, Munch, and the Russian, Kandinsky – un-Latin temperaments who found in Germany, rather than France, a sympathetic sphere. Munch and Kandinsky spent their most formative years in Germany. The latter had arrived in Munich from Russia, at the age of thirty, in 1896, just two years before the youthful Klee.

In 1892 the Secession movement took organized form in Munich, cracking open the tight control over exhibition space exercised by academic and history painters. Impressionism, Symbolism, and 'nature-lyricism' were practised by the artists, both German and foreign, who supported the breakaway in 1892. They included Franz von Stuck, who became a professor at the Academy in 1896 and taught both Kandinsky and Klee. In 1896, also, the periodicals *Jugend* and *Simplicissimus* were founded in Munich. *Jugend* (its slogan: Youth is on the March) was to give rise to the term *Jugendstil*, which replaced 'English style' as the generic name for *art nouveau* in Germany. Munich was a major centre of *art nouveau* with its insistence on the unity of 'fine' and 'applied' art and architecture, and its sometimes facile belief that the aim of all plastic art was to convey feeling or 'soul'. Practitioners of *Jugendstil* were among the first to realize that this could be done by non-objective means. Munich provided the artistic environment which supported Kandinsky and his quiet revolution. By 1911, when Kandinsky formed the Blaue Reiter group, Klee had experienced his magnetic influence and had wondered at his strange new paintings. Later the two artists were to be close friends and colleagues for many years at the Bauhaus.

Klee arrived in Munich in October 1898 and at first studied privately. He entered the Academy a year later, and after another year joined von Stuck's class. His diaries suggest a far from single-minded state at that time; they say little about the artistic problems he encountered. Instead of a further year at Munich, he travelled in Italy from October 1901 to May 1902. He sensed that his academic art education in Munich had not been a success, and he did not resume it. He was not yet able to benefit from Munich as an alternative centre of modern art. Slowly recognizing what sort of artist he was, he resigned himself to a period of self-discipline and self-education in Bern. He did not lose touch with Munich, however, for he had become engaged to Lily Stumpf and visited her there. They were married in September 1906, and Klee then settled permanently in Munich.

Modern art had flowered in Munich in the five years since he had left it. Now he could begin in earnest to catch up with recent developments in art. He saw Impressionists and Post-Impressionists newly acquired for the Neue Pinakothek. He was carried away by an exhibition of Van Gogh, and deeply impressed by Cézanne. He began slowly to meet his contemporaries in the avant-garde although his diaries say little about his reactions to them. Of those he came to know, he was closest to Franz Marc, and after him to Kandinsky. He paid short visits to Paris in 1905 and in 1912, when he met Robert Delaunay, perhaps the strongest influence outside his immediate circle. He visited North Africa in 1914 and felt a conviction that his apprenticeship was over and that he was a complete painter. Then came the First World War. Klee was not immediately called up, but in March 1916, aged 36, he was called for infantry training. It was an enforced pause in his activity, which offers an opportunity to sum up his long period of formation, with help from the voluminous diaries he kept during, and only during, this period.

Paul Klee was part poet and visionary, part disciplined, methodical craftsman and

well-regulated bourgeois. His background and education had emphasized the latter aspect; and his development was slow partly because it took him time to be equally aware of its opposite. In Italy and afterwards in Bern he was discovering himself and realizing that as a creative painter he was, in his own words, more 'poetic' than 'pictorial'. Self-realization led him to appreciate the towering contrasts and dichotomies of art, and the smallness of the individual painter before them. In a 'Recapitulation' inserted in his diary for July 1902 after the Italian tour (but presumably written some years later) he wrote: 'Now, my immediate and highest goal will be to bring architectonic and poetic painting into a fusion, or at least to establish a harmony between them.'

During the following years, Klee left scattered clues in his diaries about his transition from painstaking student of pictorial draughtsmanship to creative master of painting. In June 1905 Klee blackened a sheet of glass and drew on it with a needle. He had combined two kinds of energy – line and light: 'energy illuminates'. By 1908 he is writing more freely about the technique of painting, although on Shrove Tuesday, 1910, he professes himself 'still incapable of painting'. In March there was another and decisive step: 'and now an altogether revolutionary discovery: to adapt oneself to the contents of the paintbox is more important than nature and its study. I must some day be able to improvise freely on the chromatic keyboard of the rows of watercolour cups.'

The discoveries and realizations of that time implied the development of a world view of art and life that was not always entirely joyful: 'One deserts the realm of the here and now to transfer one's activity into a realm of the yonder, where total affirmation is possible. The more horrible this world (as today, for instance), the more abstract our art, whereas a happy world brings forth an art of the here and now.' This may be recognized as an echo of the thesis of Wilhelm Worringer in *Abstraction and Empathy*, published in 1908 and much talked of in the Kandinsky circle. By 1911 Paul Klee was not only a fully fledged painter but an intellectually formed modern artist, capable of assessing the exciting movements happening around him.

It is strange that Klee's work during his formative period is so little comparable to the quality of his insight as revealed in his diaries. In this book we illustrate only one work of before 1914, a self-portrait, *The Artist at the Window* of 1909 (Plate 1). This is an early example of Klee's use of watercolour as an independent medium and not an adjunct to drawing. There are outlines to the figure, but they are made of light coming from behind and are part of the form. The painting is composed on modern principles, that is, all the visual incidents and values in it are projected forward on to the surface as on to a screen, and are not located in space. Klee could have learned this from a number of sources, though the most likely one is Matisse, whose work he had seen the previous year in Munich, and for whom this type of composing was habitual. But Matisse's influence would not account for the particular distortions visible here. All Klee's work between 1902 and 1914 involved the problem of deformation and its expressive possibilities. Grohmann states that he went to the length of using a wrongly adjusted pantograph to obtain controlled distortions, which could suggest possibilities for new constructions.

The huge step forward taken by Klee in 1914 can be judged by comparing this self-portrait with the next pair of plates, both paintings of 1914. *Red and White Domes* (Plate 3) expresses the direct result of his Tunisian experience; *Composition* (Plate 2), although post-Tunis, relates more closely to the work of Robert Delaunay. The speculative and theoretical bent of the French artist must have been congenial to his way of thinking; possibly also Delaunay was more accessible than Braque or Picasso. Those pictures of

Delaunay that influenced Klee were a series called *Windows*, small, crystalline paintings divided into rectangles and triangles of pale, iridescent colours without linear boundaries.

It may be helpful in looking at the two Klees (Plates 2 and 3) to use the clue provided by Delaunay's title. These works can be conceived as the view outside seen through a window of small and irregular panes. Each pane attracts to itself a small segment of the total view, mingles it with light of varying intensity, imparts to it a characteristic colour and delivers it to the spectator as part of a crystalline re-structuring of the scene outside. This is a very attractive artistic idea. It neatly stands on its head the old conception of a picture as a magic window. And the use of a grid – which our small-paned window really is – to control or structure chaotic nature has a long history. It was imposed on the visible world as a *schema* or used as a practical device to enable appearances to be measured and copied. A well-known woodcut by Dürer shows an artist using such a grid. The grid is almost a symbol of measure, and has always formed the basis of classical composition. No wonder that for modern artists it has been of particular importance, sometimes all-sufficient. Klee was to have recourse to it again and again (Plates 18, 26, 28, 35).

Although Klee thought that Delaunay was moving into complete abstraction, the *Windows* are actually little more abstract than late Cézanne. Cézanne provided an even more basic precedent than Delaunay in such matters as the unifying grain of the parallel brushstrokes and the vitally important boundaries where planes of colour meet. These qualities and the delicate harmonies of the colours themselves, forming a structure of equal integrity and lyricism, show Klee making good his intention to fuse architectonic and poetic painting. It is this dualism in Klee that distinguishes him fundamentally from Delaunay (who felt nothing of the kind); in fact it is the very basis of Klee's art. In *Red and White Domes* dualism permits him the un-Delaunay-like device of inserting visual clues (absent in *Composition*), in a minor, peripheral place, which add an entire new level of meaning. The outlines of the domes themselves, and some small rectangles which can be read as windows resolve the work into a crystalline version of a North African townscape in the dying heat of the day. 'My head is full of the impressions of last night's walk', wrote Klee on the day after his arrival in Tunis. 'Art – nature – Self. Went to work at once and painted in watercolour in the Arab quarter. Began the synthesis of urban architecture and pictorial architecture'. And later, 'an evening of colours as tender as they were clear'.

Klee's war service did not cause the catastrophic interruption to his development that many artists suffered. He was not sent to the front and he escaped most of the horrors. Attached to an air force reserve unit far back in Germany, he was even able to do some painting, thanks to the small scale on which he habitually worked. He worked on damaged aircraft and used to paint their numbers and insignia. The appearance of the first war aircraft with their exposed structure, tension wires, stretched fabric and insignia, is highly sympathetic to Klee's later work and must surely have entered into his visual imagination (Plates 10 and 11). Klee sometimes used small pieces of aeroplane fabric to paint on. This was an important innovation for him. The material was relatively coarse in weave, and came into Klee's hands with irregular edges. To understand the significance of such material it is necessary to understand Klee's attitude to technical matters.

As a graphic artist Klee had been a meticulous and experimental craftsman. His 'Tunisian' watercolours were technically simple, but soon, whether prompted by his aeroplane fabric or not, he began to experiment with a great variety of techniques. This experimentation must not be confused with a restless search for 'effects'. Every 'effect'

6

used by Klee has its own proper role, and becomes inseparable from the meaning of the work. With Klee, realization and idea are one thing. That is the reason for the very concrete, material nature of his work. Although all the pioneer modern painters rejected illusionism, most were content to go on using a technique primarily designed to create illusion, i.e. oil colours on a stretched canvas, the edges of which were customarily hidden by a frame. Or they used watercolour on a sheet of paper similarly treated.

Klee used a stretched canvas very seldom indeed. When he used canvas, and he used both coarse and fine with equal judgement, he allowed the edge to show, laying the canvas down on a board. His drawings and watercolours are often mounted on a larger sheet leaving a margin on which Klee would write the title, rule a line underneath, and add the inventory number. Edges and textures were both of vital concern to Klee. The edge of a work determines its relationship with the space beyond its boundaries. Klee did not seek to create the illusion of life beyond the frame. To him, the content of the work seemed to belong naturally to the pictorial field and to exist only by virtue of it.

Look at, for example, *Fruits on Red* (Plate 31). This is painted on a red silk handkerchief used by Klee when playing the violin. The edge, and the fine quality of the thin material, dictate the style – few and fine lines, which enter from three sides, branches bearing a load of 'fruits', whose relationships to the edge of the cloth is all-important in their placing. Some of the 'fruits' are themselves small pieces of fabric. By these means Klee makes the work entirely self-sufficient – an imaginative construct raised on the foundation of a small piece of reality. Where Klee used an elaborate technique and so achieved a rich texture, it was to intensify the 'concrete' nature of the work and give its material essence a special personality. A small canvas or panel prepared in this way takes on a precious and almost venerable appearance, making us look more carefully and curiously at the imagery represented on it.

Klee was fortunate to be able to return unscathed to his home in Munich in December 1918 and resume his painting with little spiritual sense of interruption. It is true that the avant-garde circle in Munich had been dispersed. Macke and Franz Marc had been killed. Kandinsky had returned to Russia, Jawlensky had gone to Switzerland. But Klee was not dependent on a circle to be able to work and to progress. He continued to develop his ideas quietly in Munich. At least one work painted in 1918, while he was still in uniform, already establishes a type of Klee that recurred again and again over the next fifteen years and is the foundation of his later popularity: *Hermitage* of 1918 (Plate 5). Grohmann calls such works illustrations to a 'cosmic picture book'. They derive, inevitably, from the Tunisian paintings, but introduce a new feeling. The atmosphere has switched to a northern fairy tale. In the middle of a conifer forest, peopled only by birds, there is a low hill crowned by a cross, and beside it a little building with a pinnacle. There are other symbols, not readily interpreted. At top and sides Klee shows the folds of a curtain. We may be intended to see the scene, then, as a stage set, awaiting the entrance of actor or dancer. Klee was fond of the theatre, and theatrical, especially operatic, allusions are fairly frequent in his work. Surprisingly, there is no evidence of his direct involvement with the Bauhaus theatre, or any other. And he does not seem to have seen 'Les Ballets Russes', which scored such an electric success in 1909 and 1910, and continued in favour until Diaghilev's death in 1929. Klee's *Hermitage*, far from the thorough structuring of Delaunay, seems closer to the sophisticated folksiness of the stage sets designed for Diaghilev by the advanced Russian artist Natalia Gontcharova. Klee might have known

about her work from his friends Kandinsky and Jawlensky, but such a connection cannot be proved. However it came about, *Hermitage* clearly belongs to the alternative, primitivist current in modern art.

In works like that Klee establishes once and for all the ability to create a quasi-logical world having enough points of contact with the real one to provide a parallel text, so to speak, for its interpretation. These works put Klee on the level of wit and humour on which he remained for the rest of his life, even though irony was always in the background and tragedy just around the corner. Along with the humour goes a certain deliberate naivety, a childlike simplicity that often deceives the unwary into thinking Klee a lightweight artist.

In 1919 and 1920 and for a few years following, Klee consolidated what he had learnt from Delaunay by a number of tightly structured, small paintings. *Red Balloon* of 1922 (Plate 6) is one of the later of these. It is in oil, but applied to muslin primed with chalk and mounted on a board, a typically Klee technique resulting in translucency of colour contrasting with the evident texture of the support. Almost everywhere the planes of colour are bounded by lines, one of the most obvious differences with a painting of 1914 like Plate 3, and with the denser, more richly painted oils of 1919 such as *Villa R* (Basel). There is still the underlying basis of a grid composition, but it is not carried over the whole space. The relationship between the content and the abstract form is much the same.

In *Red Balloon* a brilliantly designed linear and colour composition of great charm offers a fairly specific interpretation. The interconnected rectangles stand for balconies, window-shutters and door, with the whole design keyed into place by the sloping roof top right. Bottom left a little square or yard appears, beyond it a large gate, the beginnings of roofs, a domed building which is perhaps a plant-house, as faint tree-like outlines can be seen within it (the Botanical Garden is a favourite theme of Klee's). The most specific image is the balloon itself with its basket and cable. The imagery is in no way laboured, the interpretation if offered rather than demanded. The basis of Klee's detachment in that respect is his growing confidence and skill in handling abstract elements. We can study how he used them in another painting of near this time, *Senecio* of 1922.

Senecio (Plate 7) is one of the works that the thoughtless might dismiss as 'childish', although it is pure vintage Klee. It has a somewhat obscure title – *Senecio* being the botanical name of the genus including cineraria and ragwort. Klee is probably comparing the moon-faced person with the round flower of *Senecio*, the eyes with the shape of the petals and the pupils with the prominent seed-heads of cineraria. He was often to return to these round heads in future years (Plates 36 and 37). If the content here is not very significant, the construction was important to Klee. Anyone who thinks seriously about abstract design must soon be led to ponder the relation between the circle and the square. Plates 6 and 7 show different ways of playing them against each other. *Senecio* cunningly absorbs the circle into a rectilinear structure still dependent on Delaunay. Klee was always able to give the circle a special potency (Plates 30, 31 and 34).

How important was it to Klee that his works should be *read* in such ways? His views are made plain in the speech he gave at the opening of an exhibition of his work at Jena in 1924, published in English as *On Modern Art*. Klee is most af all concerned to describe what he called 'the specific dimensions of pictorial art', the use of which must, he says, be accompanied by distortion of the natural form; 'for therein is nature reborn'. But the question for us is: how are we to recognize and name this re-birth? To Klee, the choice of

formal elements and their mutual relationships is analogous to musical thought. He devotes much time to discussing how the process of creating an image in this way proceeds, and then continues: 'with the gradual growth of such an image before the eyes an association of ideas gradually insinuates itself which may tempt one to a material interpretation. For any image of complex structure can, with some effort of imagination, be compared with familiar pictures from nature.' This is a particular source of misunderstanding with the layman, and danger to the artist if he allows himself to be diverted from the business of composing – building or balancing, to use Klee's terms – his pictures. 'But sooner or later, the association of ideas may of itself occur to the artist . . . Nothing need then prevent him from accepting it, provided that it introduces itself under its proper title.' And having accepted it the artist may well think of additions to enhance the representative element.

Klee was invited to join the Bauhaus at Weimar in November 1920. The Bauhaus, founded in 1919 by Walter Gropius, was the perfect theatre for Klee to unfold his teaching methods. Not an art school, it was devoted to re-uniting the fine and applied arts, and architecture, in a manner suitable for an industrial age. The role of the painters was not to teach painting but to inculcate an understanding of form. The programme had a sociological bias and a community-based system of instruction, aspects that led the Bauhaus into severe political and internal trouble. In April 1931, two years before it was finally closed by the Nazis, Klee resigned to take up a professorship at the Düsseldorf Academy of Fine Arts. But he held the post for only two years before the Nazi campaign against modern artists brought about his dismissal. Sadly, Klee left Germany to return to Bern, where his father still lived.

Klee's invitation to join the Bauhaus was a kind of fulfilment, and he entered enthusiastically into his work as a pedagogue. He found, like other masters, that he had to work out a written code of practice as he went on, not only to have a teaching aid but to clear his own mind about procedures that were largely unconscious. He produced an enormous body of didactic writing, little of which was published in his lifetime, but which appeared in two extensive volumes in 1961 and 1973 (English editions). Klee did not think that this exacting preparation for teaching was an interference with his painting. The two things re-inforced each other: 'everything must go together or it wouldn't work at all', he wrote.

In his writings and demonstrations, Klee proceeds from first principles to a long analysis of the means available to embody them. In setting out his principles he is concerned not so much with 'art' as with dualism, antithesis, orientation, growth, movement; in other words the bases whereby human beings realize their existence in the world. Klee first had to make his pupils think of their task of form-production in these terms, then to re-orient themselves to the world through their exercises.

In practical terms, Klee's pedagogy rested on the belief that 'everything that happens in a picture must have its logical justification'. Faced with the weight of evidence that Klee assembled to make this contention possible, we accept it without demur. Yet it conflicts with nearly everything that the public has been told about the way art and artists work. Where then does the truth lie? It may be said that all Klee's elaborate teaching had no sequel, did not produce a school of logical painters. Yes, but we have seen that the Bauhaus did not set out to produce *painters*, and Klee's courses certainly helped the Bauhaus to be the immense influence it generally was, in spite of the Nazi years that followed. And since their publication the pedagogic books have been highly valued by

logical, numerate artists of the present. On the other hand unbridled 'intuition' has had a great following among painters, and has produced its flashes of light as well as a great deal of obscurity, but it is considered inadequate for the complex situation of today.

As so often, one must look for a synthesis. Of all artists, Klee is the most *effectively* intuitive, just because by logical thought he was able to refine his means to give instant and accurate form to each intuition. There came a time when this great artist had no more need to go on refining his system. Even before giving up teaching he had grown tired of elaborating it. From 1933 until his death in 1940 a progressive simplification of his means accompanied a progressively more intense and powerful expression.

The Bauhaus years were the years of greatest technical variety and invention of form for Klee. A selection of forty-eight plates is certain to miss out works that some people will think the essential Klee, but the works reproduced in this book range from the most abstract to the most figurative, from the architectonic to the poetic, the static to the dynamic. In atmosphere they include the innocent and the highly-charged. The means extend from pure line to the most sophisticated combinations of line, tone and colour and back to simple chromatic grids.

One aspect of the 'essential' Klee will be for some people the fascinating *Twittering Machine* of 1922 (Plate 10). Here the means are economical but sophisticated – a sheet prepared with an old-looking priming of pinkish-grey watercolour, which received an ink line with a rough edge like an etching. Against this worn surface is performed an absurd concert, forcefully suggesting a crazy automaton made of wire with a crank on which four bird-like creatures are mounted. The rise and fall of these piercing creatures is connected, in no very logical way, with the movement of the crank – we see their heads and tongues at various stages of voice-production. Here the thin wavy line and taut structure are perfectly matched to the shrill noise we can expect to hear; also the structure is almost disembodied and floats high above any contact with the ground, indicating that such a high-pitched clamour seems to have little natural reason. *Tightrope Walker* of 1923 (Plate 11) belongs to the same group of works. Here the little stunt man caught in the crossed spotlight beams is an extreme symbol of balance, and he presides over a structure which is intended to represent this balance of forces in a more diagrammatic way. The picture field is intersected by the light beam giving an off-centre axis for the whole structure as delicately balanced round this axis as the stunt man on his wire.

Another 'essential' work by Klee may be for some *A Young Lady's Adventure* of 1921 (Plate 13), which is in the Tate Gallery. Here Klee shows how to combine line and planes of colour in a way essential to his later work. A very free-flowing line spontaneously creates, as it curves and intersects, a whole repertory of interlocking shapes (compare Plate 24). On this foundation is placed a series of delicately graded watercolour washes that establish planes of space and distinguish objects from ground, though not very clearly – the girl's cape and arms merge into the background. The subject is one of the comparatively rare erotic references in Klee, although it is generally taken as playful. A startling red arrow points to the nature of the 'adventure' and the same colour is used for at least one other sexual sign, the extended organ of a little animal in the bottom left corner. Klee had used a 'beast' as a symbol of frustrated male desire in one of his early etchings, but far more portentously than this. Perhaps the *Young Lady's Adventure* is an ironic comment from the safety of Klee's maturity on the anxieties of his early youth.

Other different uses of line can be seen most notably in Plates 16 to 19, 24 and 25. Compare for example Plates 24 and 25. Both are of the 'walking line' variety – meaning

not just that the line is continuous but that it obeys its own compulsion, producing form virtually as a by-product. The *Little Jester in a Trance* is drawn with almost a single line, and a set of line monoprints of two years before show this line unadorned, coming close to the idea of 'automatic' drawing put forward by the Surrealists a year or two earlier. In the sheet illustrated Klee tidies up the intersections, adds the eyeball; and by adding tones within the intersected lines he introduces a cubist-like pseudo-modelling, a shallow penetration of the surface, with jagged edges suggesting the clothes of the Jester.

Threatening Snowstorm has lines keeping company and passing right across the field. As these lines only travel in the horizontal and vertical dimension, we form the idea of buildings, and so we see a town under a heavy winter sky, rendered in Klee's spray technique. Klee uses the same convention to convey towns and habitations on other occasions.

With *Carnival in the Mountains* of 1924 (Plate 16) we are in a different world of line. The teachable structure of his work has fallen into the background and Klee's Gothic imagination, prominent in the early etchings, has re-asserted itself. Line is not used here for structural clarity but to create by cross-hatching a smoky, obscure space peopled by sinister beings. Note that Klee's use of hatching is mainly (to use his teaching vocabulary again) exotopic and not endotopic – that is, the hatching and modelling define the background and not the objects on it, underlining their non-substantive nature. Klee seldom gave such detailed expression to grim fantasy in his middle life. The blind girl and child, the monster holding an eye, are like a Gothic equivalent of Picasso's more famous *Minotaur* etchings in the thirties. *Botanical Theatre* (Plate 17) is an even more elaborate example of the 'exotopic' use of hatched line, to more fanciful and less highly-charged effect. This must count as one of the most highly developed works in Klee's whole output, and he worked at it, unusually, over a period of ten years.

Still another use of line is seen in a number of works such as *Castle to be Built in a Forest* of 1926 and *Pastorale* of 1927 (Plates 19, 18). Here we are back with more 'teachable' matters, meaning that the effects are capable of analysis. The sequence ending in *Pastorale* begins with some drawings in ink on damp paper, similarly set out in a rhythmical, musical way. These works may be too easily dismissed as 'pattern'. They certainly employ repetition, but always with variety of detail – as in music. The musical analogy extends to a marked resemblance to musical scores. An important part of Klee's teaching dealt with the rhythm of structures. The whole course of his work led to the invention and refinement of pictorial *signs* which he used to obtain the most amazing para-human figuration and emotional expression. The fruits of this development were at their finest in his late period. Meanwhile here in these 'patterned' works structure, rhythm and sign join in a richly varied embroidery, capable of suggesting many parallel meanings. Klee's titles for these works often have botanical references, such as *Ripe Harvest* or simply *Horticulture*. This need not surprise us, as variety within repetition is characteristic of nature and of gardens. Sometimes, by a slight alteration of the sign-language, Klee suggests the presence of streets and buildings alternating with planting. *Pastorale* has a very built-up texture into which the lace-like lines are indented, so that the whole work takes on a tactile and mysterious quality, like an ancient tablet with some runic message on it.

These drawn works lead straight to a group of brush paintings as delightful as any Klee ever did (Plates 22 and 23). In the brush paintings, the parallel lines become strokes of the brush, uniting line and colour. Nature is no longer petrified, but intensely luminous, as Klee deploys the colour against a dark ground. *Gate in the Garden* (Plate 23) also looks

forward to the late works psychologically, since the gateway, the red rectangle in the upper left corner, resembles the symbols of life and death found in them.

We have not considered these works in strict chronological order. That does not mean there was not an underlying evolution. The trend was always in the direction of economy of means, fewer purely pictorial details, less dynamism. This tendency already appears in the abstract paintings from 1923 (Plate 27) which re-assert the importance of the grid concept, of architecture, and of Delaunay, in a more pure and resonant musical way than before. These, in their rhythmic variety, are far from the rigidity implied by the word 'grid'. They lead one directly to a series, apparently abstract too, which is connected with Klee's short visit to upper Egypt in the winter of 1928–29 (Plates 28 and 29). In one way these are even closer to the *Pastorale*, being based not on a grid but on a series of horizontal layers, which Klee now called *strata*. The strata are joined, articulated and divided in the same musical way as the *Pastorale* is, but they do not bear the load of signs. Instead, they are given a solid substance appropriate to the new geological and topographical meaning Klee wanted them to convey. *Monument in Fertile Country* (Plate 28) is the most directly related to upper Egypt. The landscape of that country is the most clearly structured imaginable. The great artery of the Nile is flanked on each side by a narrow band of fertile land sharply defined by irrigation ditches at right angles to the river. Beyond a further band of half-desert an austere escarpment of naked rock rises. Into this landscape are fitted the immense stone monuments of ancient Egypt. Klee's painting is an exact analogue of this scene and echoes its clarity. On the left and right we see the cultivated strips, some with crops, some fallow. In the middle, larger units of pink and sandy colour denote the huge blocks of temple or colossus. Some diagonal lines suggest an element of space in what would otherwise be a map-like representation. Egyptian influence of a different kind may be seen in *Ad Marginem* (Plate 30), where among Klee's personal sign-objects disposed around the four edges of the work stands a wading bird straight from Egyptian painting. The huge sun-disc moreover and some of the signs themselves suggest a similar origin. This work is an interesting example of centrifugal composition and illustrates Klee's liking for edges and his idea of all-round orientation; the work is an object independent of direction or of the wall.

That these 'Egyptian' works foreshadow the last phase is not disproved by the existence of contemporary or later works such as Plates 32 and 33, which seem still to belong to the world of Bauhaus instruction. The same reductive tendencies are at work on them too. The unusually large painting *Ad Parnassum* (Plate 34), painted in Klee's Düsseldorf years, is truly transitional between the Bauhaus and the late period, although it too clearly shows an Egyptian image. This belongs to a group in which Klee employs spots of colour in a way akin to mosaic. Klee had visited Ravenna in 1926 to see the mosaics, but the idea of building up a picture from very small units was already consistent with his thinking. In some of this group the spots are indeed square and close together, but in *Ad Parnassum* they are round, and show some of the ground between them. There is a somewhat impersonal grandeur, rare in Klee, about this canvas and also the wholly abstract canvas *Polyphony* (Plate 35), executed in the same technique. These and a few others are culminations in every sense – fruits of long technical preparation and intensive thought especially on the musical qualities of painting; coming at the end of a distinguished career of teaching and painting, which had brought him extensive fame. The intense individuality of Klee which makes him so much *sui generis* that his work will not hang easily with others is temporarily

reduced in the early thirties, only to re-appear again with retirement and illness. Helped by their larger size, these works would appear as key works in any museum of modern art that was fortunate enough to possess them, effortlessly surpassing the noisier and often much more recent works of other artists in the same vein.

Klee was dismissed from his teaching post at the Düsseldorf Academy in 1933. In December 1933 he returned to Bern and to a simple, disciplined and very private existence, such as he had always preferred. In the summer of 1935 the symptoms of his fatal illness appeared. Its ravages can be seen in the photographs taken in the following years but, except in 1936, he continued productive to the end, which came in June 1940.

Dismissed from public life and from the country he regarded as his own, depressed by the Nazi tyranny which pilloried him as 'degenerate', constantly ill, how could his work fail to reflect all this? It is remarkable that Klee never lost his puckish humour, which was a necessary ingredient in his expressionism, but his true late period, which runs from 1935 to 1940, is marked by great changes.

These changes can be considered under technique, composition and expression. Greater simplicity marks the two first; greater intensity the third. Line drawing, of course, continued all the time. Alongside it a method of drawing with the brush developed, a thick brush whose heavy emphasis needed the crispest and most assured handling and far exceeded the later work of the abstract expressionists in its capacity to reveal the artist's mind and soul. This method embraced both painting and drawing and came to a peak in 1939 and 1940 (Plates 46 and 47). Klee's liking for coarse canvas became stronger, and in the last works colour seems rubbed in, rather than painted on this canvas, giving an effect both dry and compelling in conjunction with a great black line (Plate 48). Other technical effects at this time are directed to rough, primitive appearances.

The overriding change in Klee's late method of composition was the breaking down of his former flowing line and rhythmic repetitions into separate units. The peak of the 'disjunctive' method of composing comes in several paintings of 1938 (Plates 42 and 43). These lovely works come before the final, grim outpouring of images when Klee knew that he was going to die; therefore they have the strength and the quality of surprise imparted by the late style, without its greatest asperities. *Red Waistcoat* (Plate 42) still has much of the charm of earlier years as well. The broken line of late Klee, resulting in the distribution of 'signs' or ideograms over the whole picture field, is one of the few new inventions since cubism – from which, indeed, Klee may have partly derived it. It is a development of the cubists' idea that paintings do not serve to locate images in space but to suggest relationships. Klee's fragments of discontinuous line cannot possibly be used to locate images, but they cause the whole picture field to come alive with possible relationships. The notion of location has been replaced by that of *interval*, which exists all over the field as a power of attraction or repulsion. In Plates 42 and 43 there is no dominant feature, no hierarchy within the picture, which is presented as a totality.

It is difficult to be dispassionate about the composition or technique of Plates 46 and 47 when they are so obviously the expression of emotion in the face of impending death. These are the final culmination, and they come at the end of a period when Klee's titles more and more direct the viewer to numinous experiences, malign forces and the human beings who are their instrument. The discontinuous style was uniquely suited to convey these, although we saw above that it need not do so.

The work of Paul Klee, of all periods but especially the last, has been of enormous importance in the development of modern art. Its effect was delayed by Fascism in

Germany and perhaps by a lack of acceptance in France, but since the last war it has been constantly increasing. Klee had at his command a greater variety of formal invention than any other modern master. Almost alone he never succumbed to pressure to repeat himself or to the forces that make for decline in famous artists. His whole late work was a manifesto and act of bravery, for it was far less easily acceptable than what had gone before. Above all it is by his intellectual capacity that Klee dominates his contemporaries, none of whom, not even Kandinsky, could think through the full implications of what they were doing as he could. Many talked about a new relationship between art and nature; only Klee actually tried to define it, and with considerable success. At a time of uncertainty and loss of direction in art he is a source of confidence and admiration.

Outline Biography

1879 Born in December at Munchenbuchsee near Bern, son of music teacher Hans Klee and Ida Maria Frick.

1898 Graduates from *Literarschule*, Bern.

1898-1901 First Munich period. Studies first at the private art school of Erwin Knirr, then at the Academy of Fine Art.

1901-02 Travels in Italy.

1906 Marriage to Lily Stumpf. Second Munich period until 1916.

1910 Exhibition in three Swiss cities.

1911 First one-man exhibition in Munich. Klee begins the catalogue of his work, retrospective to 1883.

1914 Visit to Tunisia, April.

1916-18 Service with the German Army.

1921 Joins the Bauhaus in Weimar.

1923 First pedagogic work published in the *Bauhaus-Buch*.

1924 First exhibition of Klee in U.S.A.

1925 Bauhaus moves to Dessau.

1931 Appointed to the Düsseldorf Academy of Fine Art with effect from 1 April.

1933 Dismissed from Academy under Nazi pressure. Settles in Bern again.

1934 First Klee exhibition in Britain.

1935 First symptoms of his fatal illness (later diagnosed as sclerodermia). Large exhibition at Bern and Basel.

1937 Klee's work confiscated from German museums and included in 'Degenerate Art' exhibition in Munich.

1940 Death of Klee at Muralto-Locarno, 29 June.

37. *The Future Man.* 1933. Watercolour applied by spatula, 61·8 × 46 cm. Bern, Klee Foundation.

38. *Contemplating.* 1938. Paste colour on newsprint, 47·2 × 65·8 cm. Basel, Galerie Beyeler.

39. *Jewels.* 1937. Pastel on cotton, mounted on canvas, 57 × 76 cm. Düsseldorf, Kunstsammlung Nordrhein-Westfalen.

40. *Outburst of Fear.* 1939. Watercolour on paper prepared with tempera, 63 × 48 cm. Bern, Klee Foundation.

41. *Rosebush.* 1938. Paste colour on writing paper, 28 × 17·8 cm. Düsseldorf, Kunstsammlung Nordrhein-Westfalen.

42. *Red Waistcoat.* 1938. Paste colour, waxed, 65·1 × 42·5 cm. Düsseldorf, Kunstsammlung Nordrhein-Westfalen.

43. *Park near Lu(cerne).* 1938. Oil on panel, 100 × 70·2 cm. Bern, Klee Foundation.

44. *Walpurgis Night.* 1935. Gouache on fabric, 50·8 × 47 cm. London, Tate Gallery.

45. *Woman in Native Costume.* 1940. Paste colour on paper, 48 × 31·7 cm. Bern, Klee Foundation.

46. *Kettle Drummer.* 1940. Paste colour on paper, 34·4 × 21·7 cm. Bern, Klee Foundation.

47. *Death and Fire.* 1940. Oil on panel, 46 × 44·1 cm. Bern, Klee Foundation.

48. *Aspiring Angel.* 1939. Gouache, 48·5 × 33·5 cm. Private Collection.

Owing to production problems, several plates have been included which were not part of the author's original choice.

Bibliography

W. Grohmann: *Paul Klee*, Lund Humphries, 1954. (This is still the best comprehensive work, by an author who knew Klee and first wrote on him in 1924.)

C. Giedion-Welcker: *Paul Klee*, New York, Viking Press, 1952.

W. Haftmann: *The Mind and Work of Paul Klee*, Faber and Faber, 1954 and 1967.

G. di San Lazzaro: *Klee; a study of his life and work*, New York, Praeger, 1957.

Felix Klee: *Paul Klee. His life and work in documents.* Braziller, New York, 1962.

C. Geelhaar: *Paul Klee and the Bauhaus*, Adams and Dart, 1973.

Berner Kunstmuseum:

The works by Klee in the Kunstmuseum, Bern, most of them in the Klee Foundation, are being catalogued in four volumes. The following have appeared, by Jurgen Glaesemer:

 1. Gemälde, Farbige Blätter, Hinterglasbilder und Plastiken.

 2. Handzeichnungen I; Kindheit bis 1920.

Paul Klee: *The Diaries of Paul Klee, 1889–1918.* Edited with an introduction by Felix Klee, University of California Press, 1968.

Paul Klee Notebooks. Volume I published in English 1961 (Lund Humphries), as *The Thinking Eye.* Volume 2 published in English 1973 (Lund Humphries), as *The Nature of Nature.*

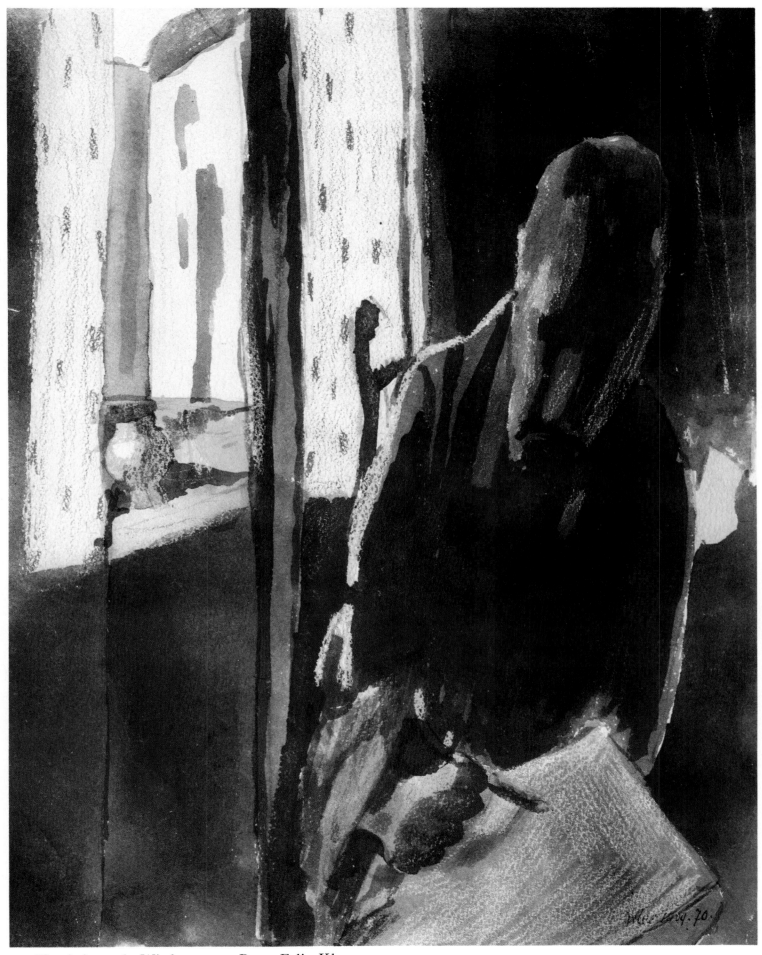

1. *The Artist at the Window*. 1909. Bern, Felix Klee

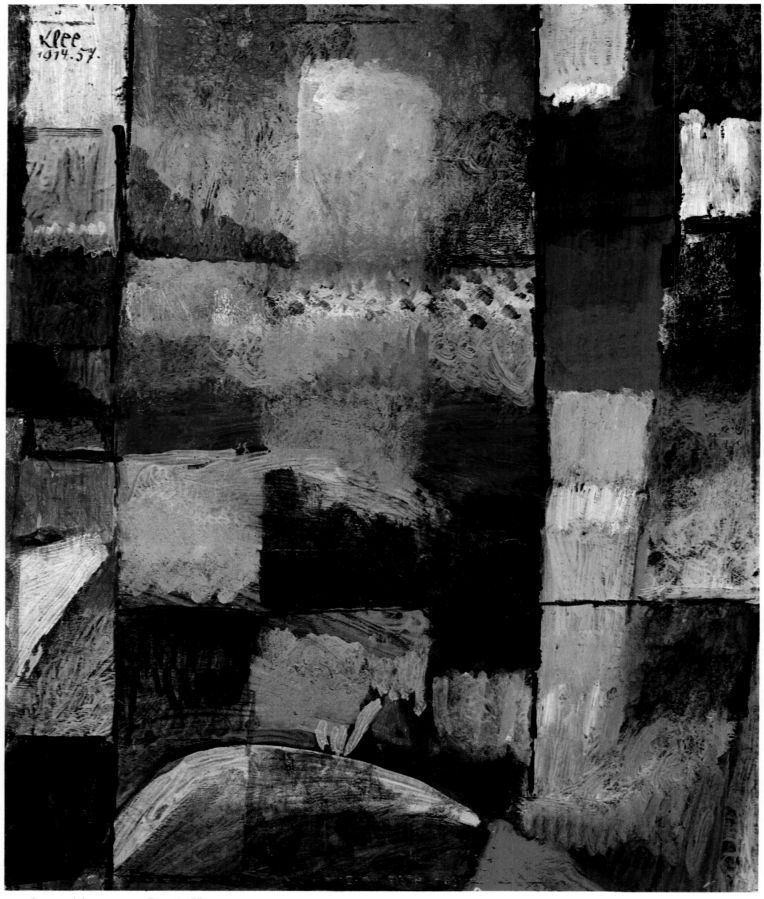

2. *Composition*. 1914. Basel, Kunstmuseum

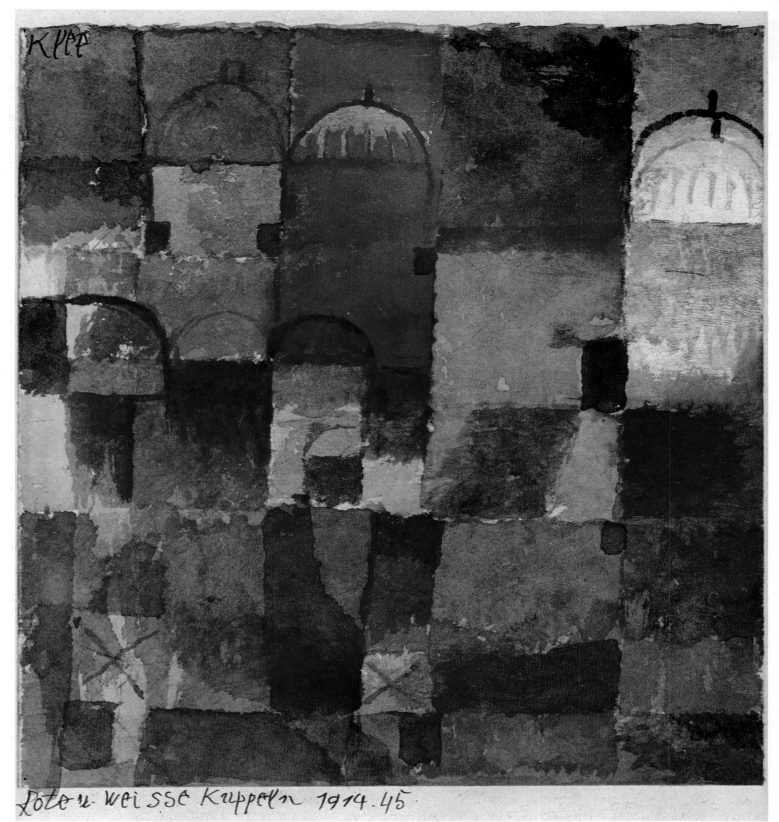

3 *Red and White Domes*. 1914. Düsseldorf, Kunstsammlung Nordrhein-Westfalen

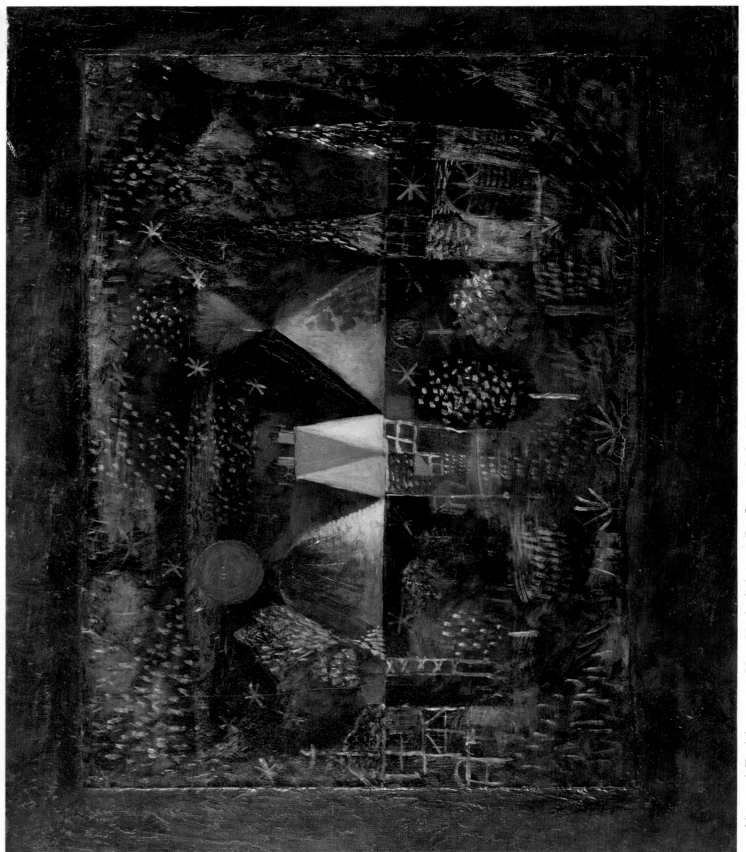

4. *Nocturnal Festivity*. 1921. New York, Solomon R. Guggenheim Museum

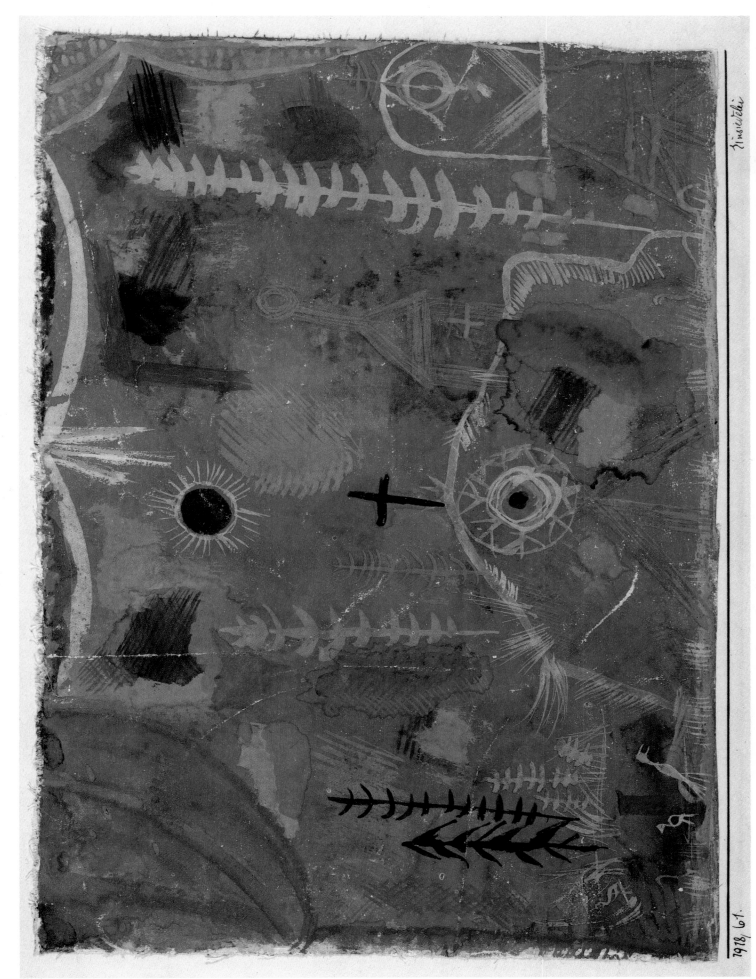

5. *Hermitage.* 1918. Bern, Klee Foundation

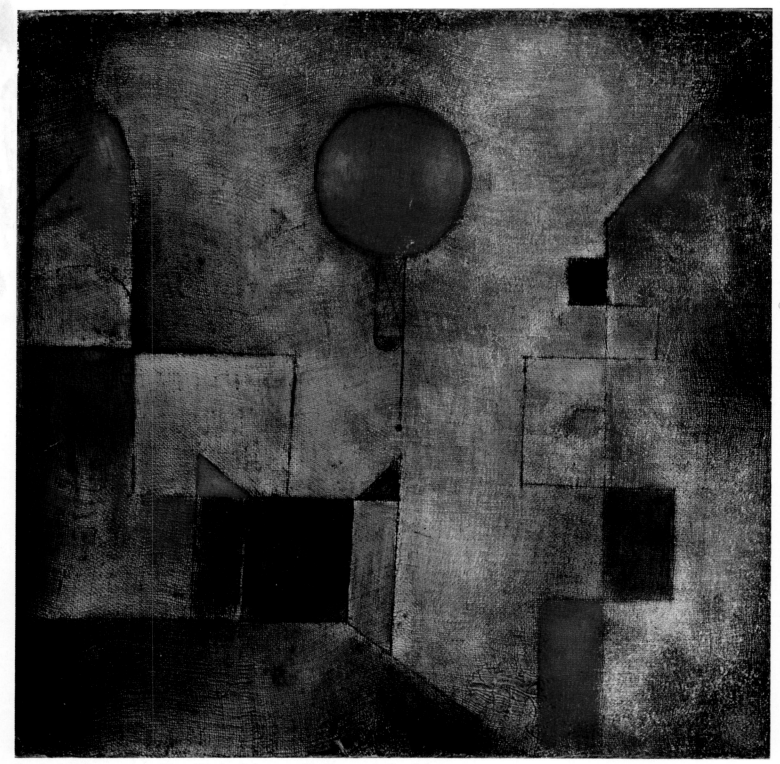

6. *Red Balloon*. 1922. New York, Solomon R. Guggenheim Museum

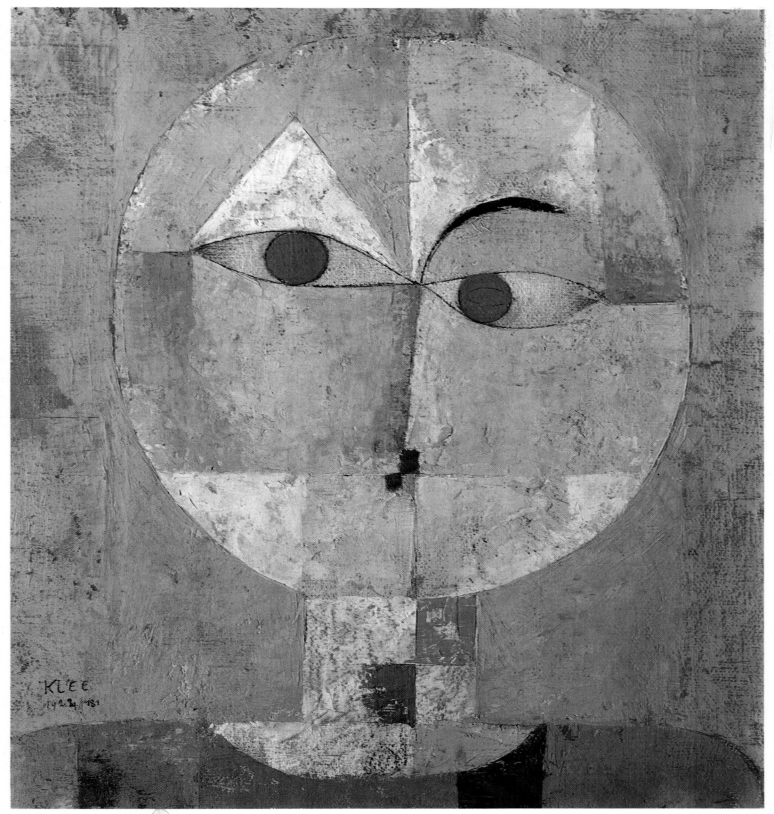

7. *Senecio*. 1922. Basel, Kunstmuseum

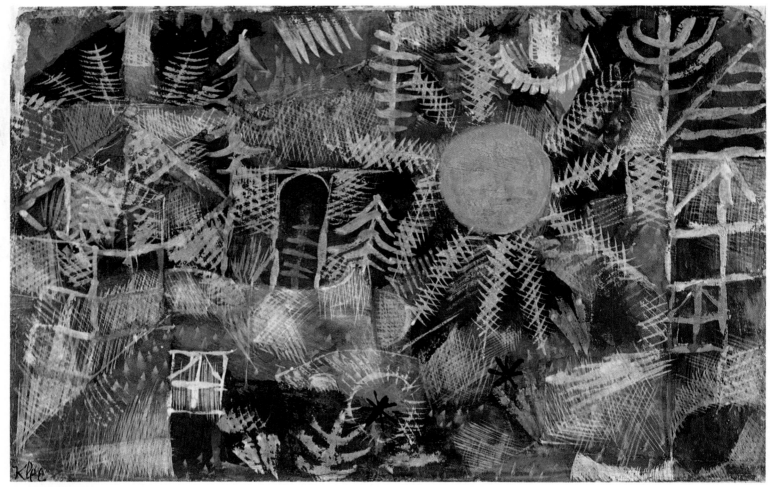

8. *Growth in an Old Garden.* 1919. London, Fischer Fine Art Ltd.

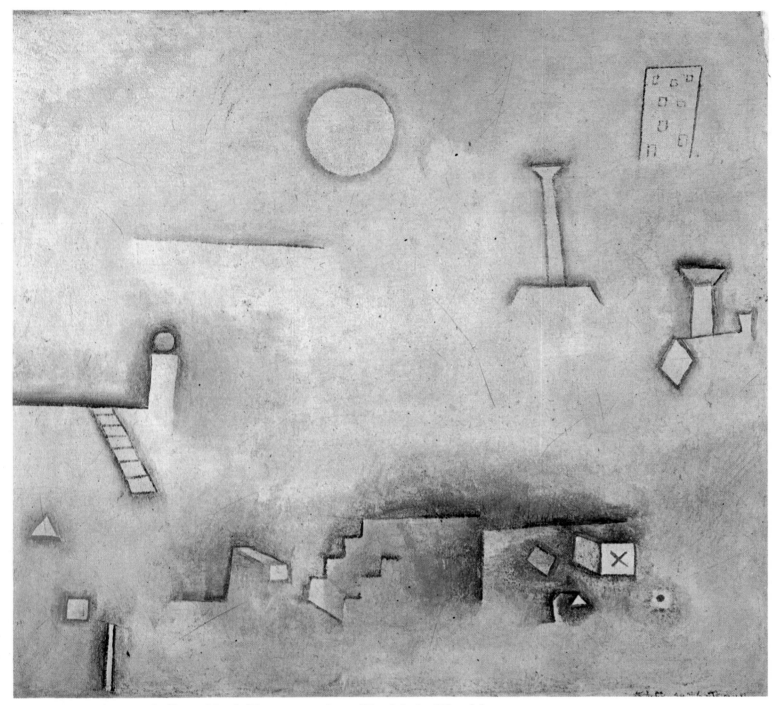

9. *Reconstruction*. 1926. Düsseldorf, Kunstsammlung Nordrhein-Westfalen

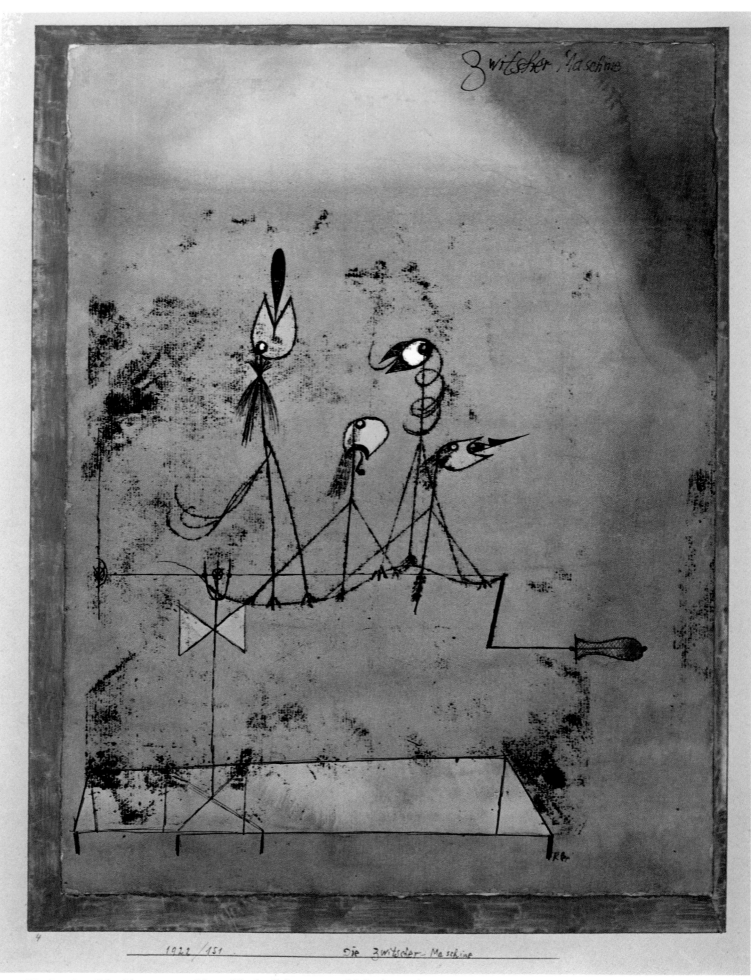

10. *Twittering Machine*. 1922. New York, Museum of Modern Art

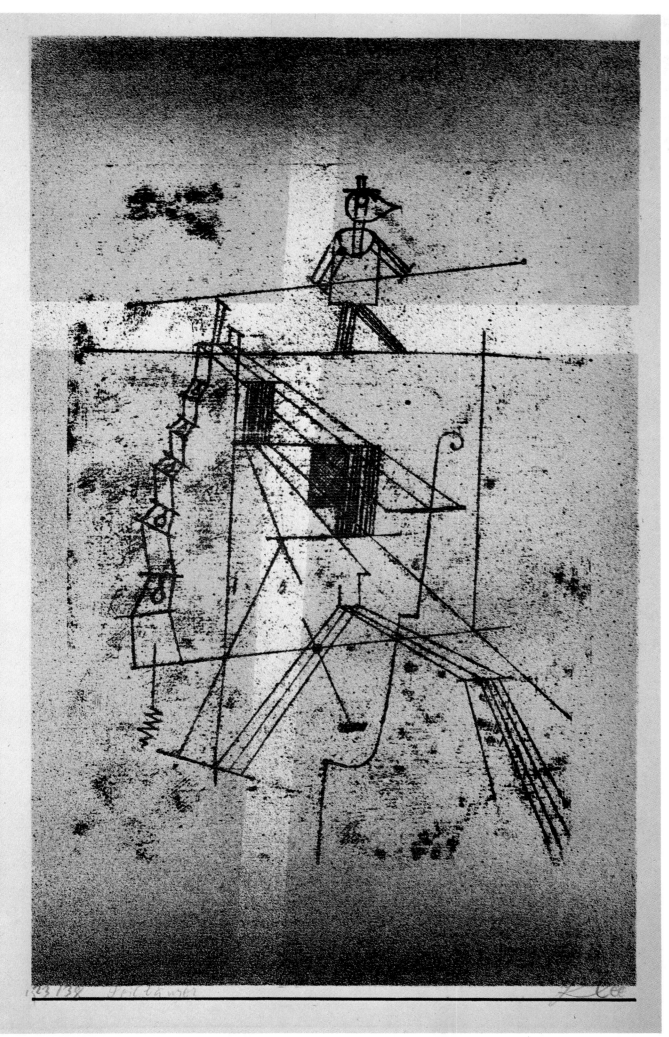

11. *The Tightrope Walker.* 1923. Edinburgh, Scottish National Gallery of Modern Art

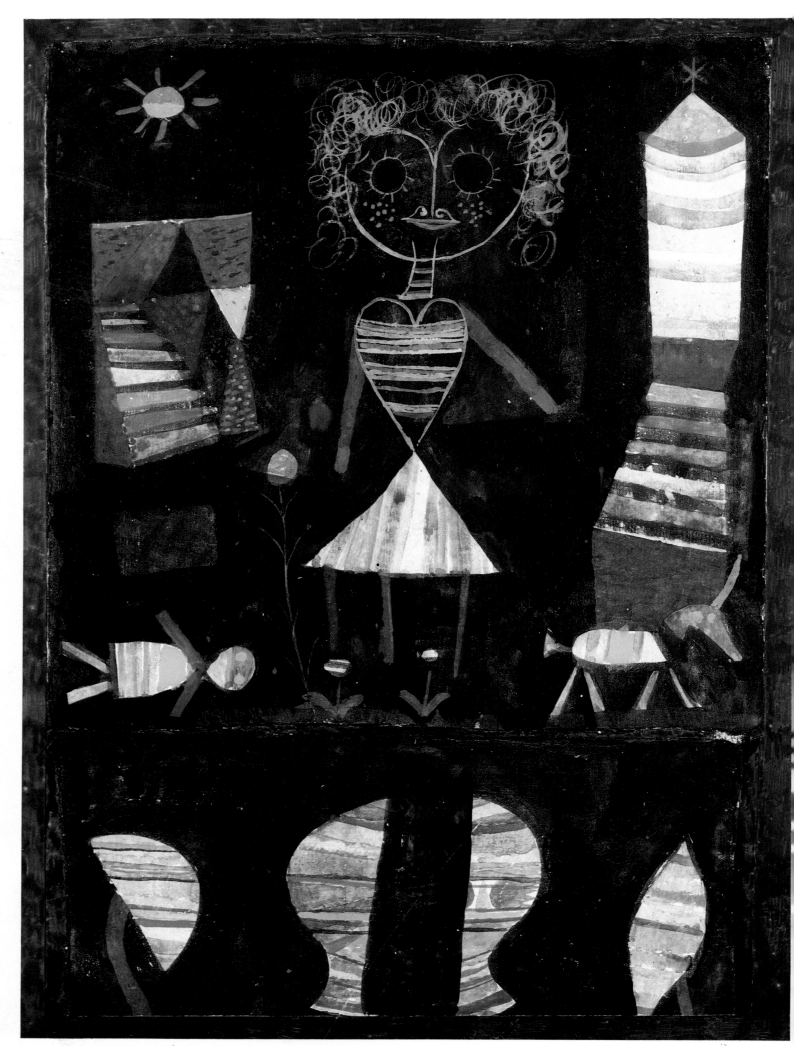

12. *Puppet Theatre*. 1923. Bern, Klee Foundation

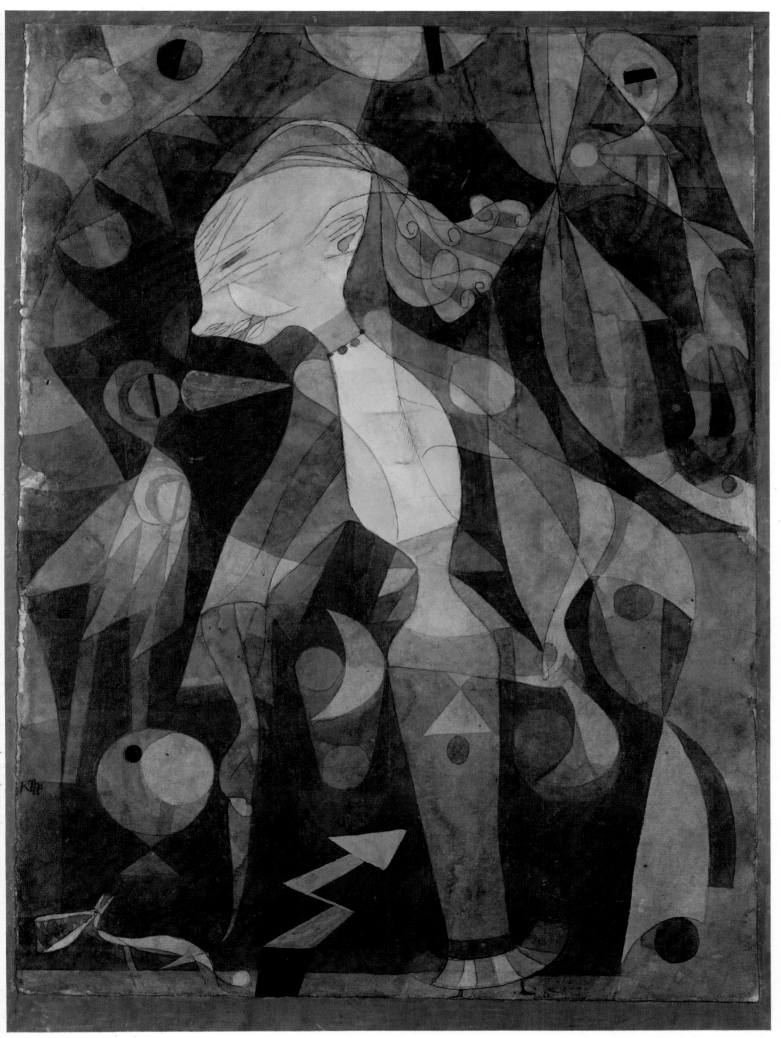

13. *A Young Lady's Adventure.* 1921. London, Tate Gallery

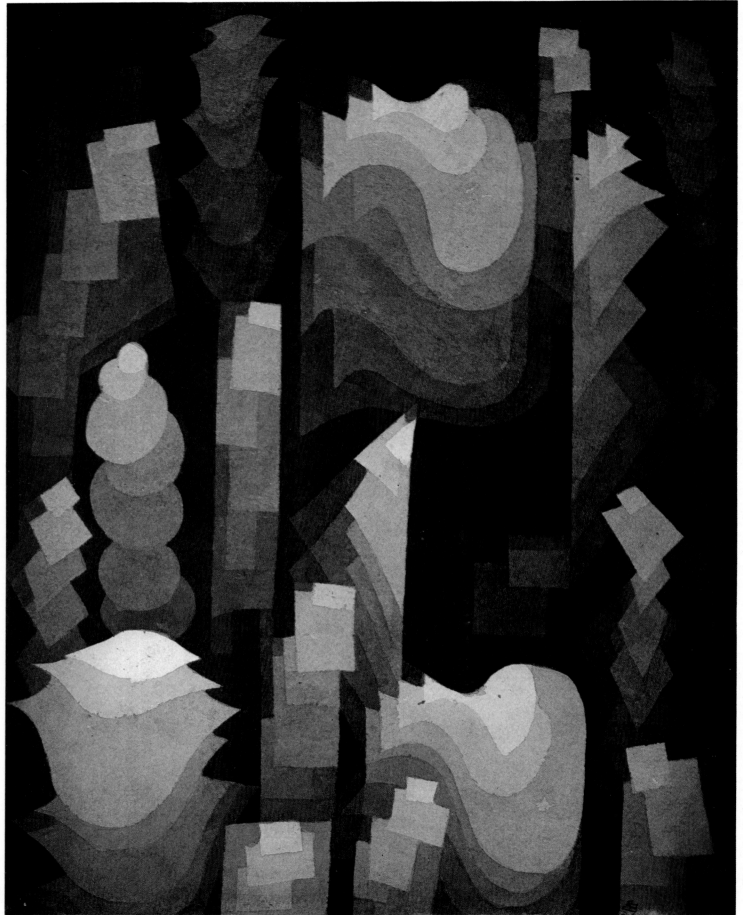

14. *Fugue in Red.* 1921. Bern, Felix Klee

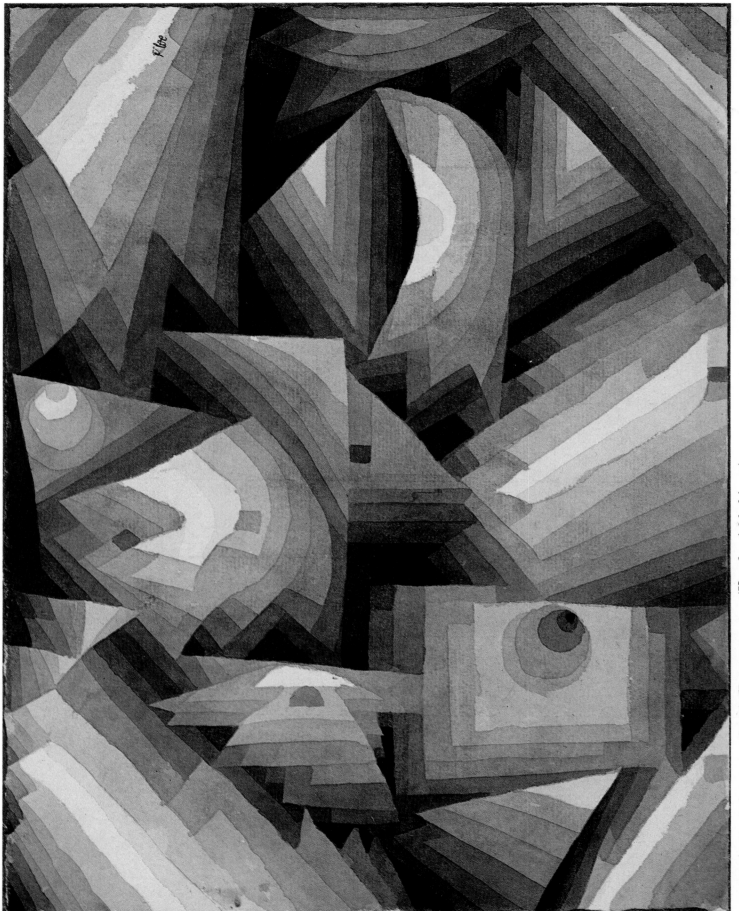

15. *Crystal Gradation.* 1921. Basel, Kunstmuseum (Kupferstichkabinett)

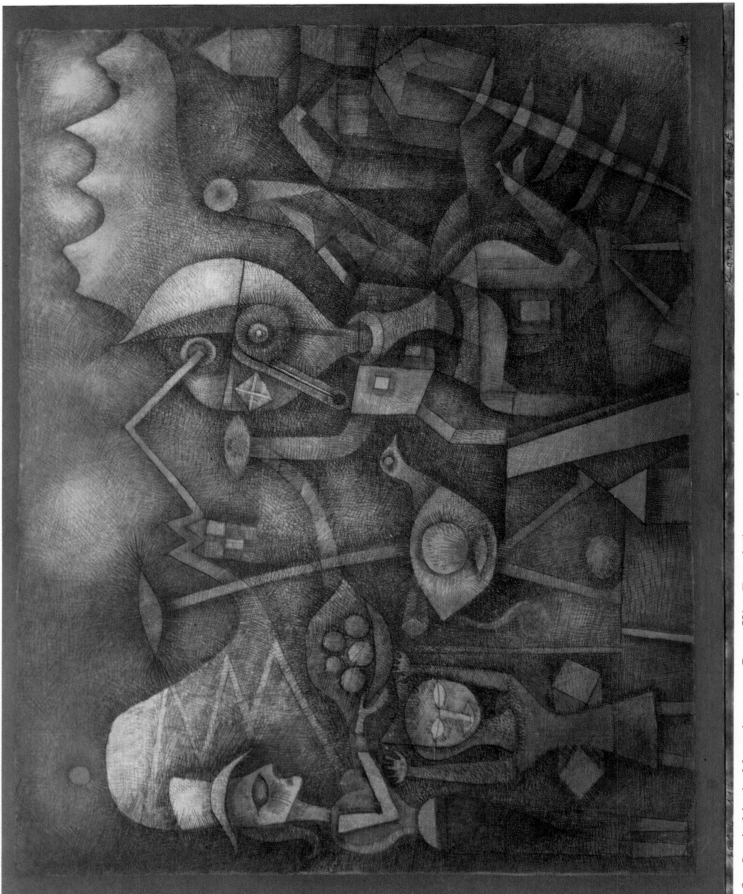

16. *Carnival in the Mountains.* 1924. Bern, Klee Foundation

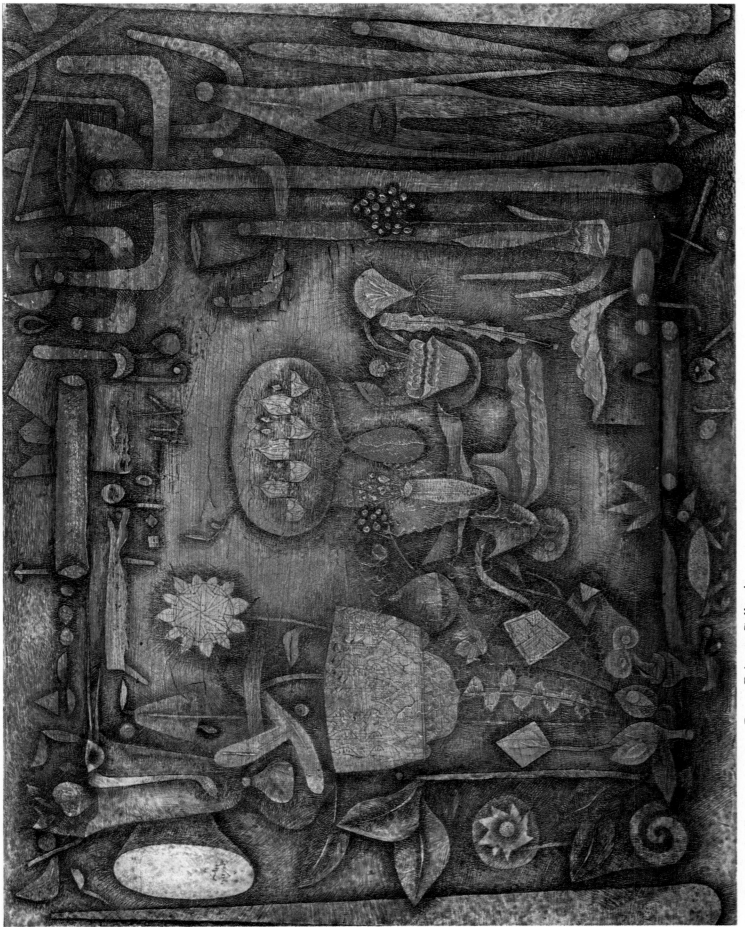

17. *Botanical Theatre*. 1924/34. Bern, Private Collection

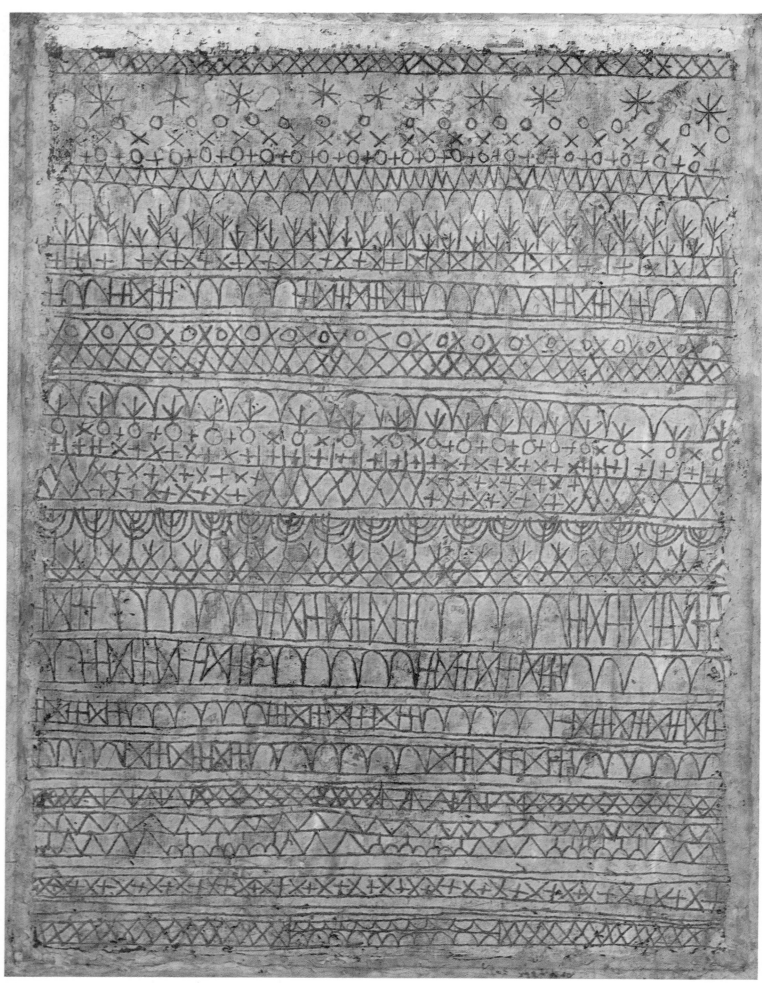

18. *Pastorale*. 1927. New York, Museum of Modern Art

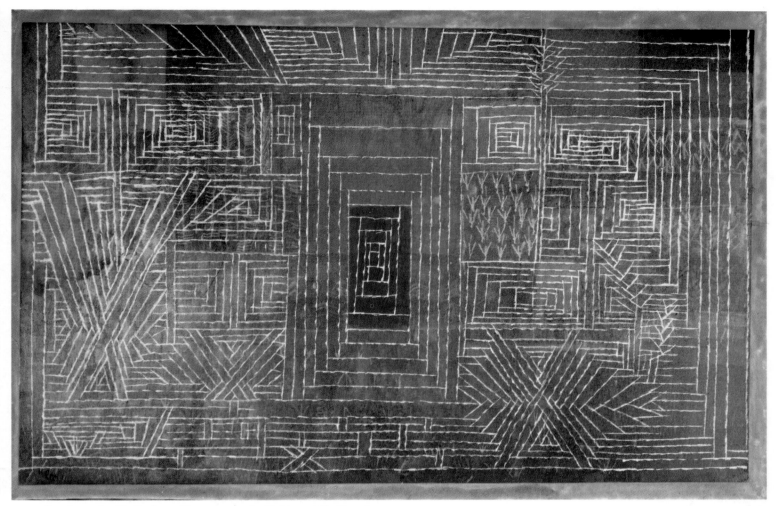

19. *Castle to be Built in a Forest.* 1926. Private Collection

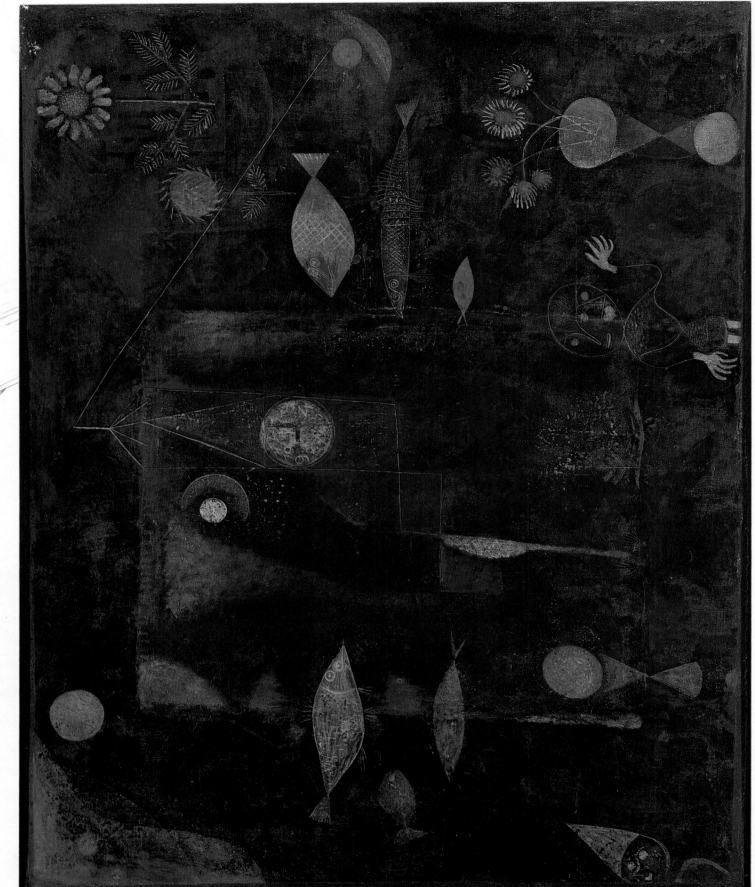

20. *Fish Magic.* 1925. Philadelphia Museum of Art

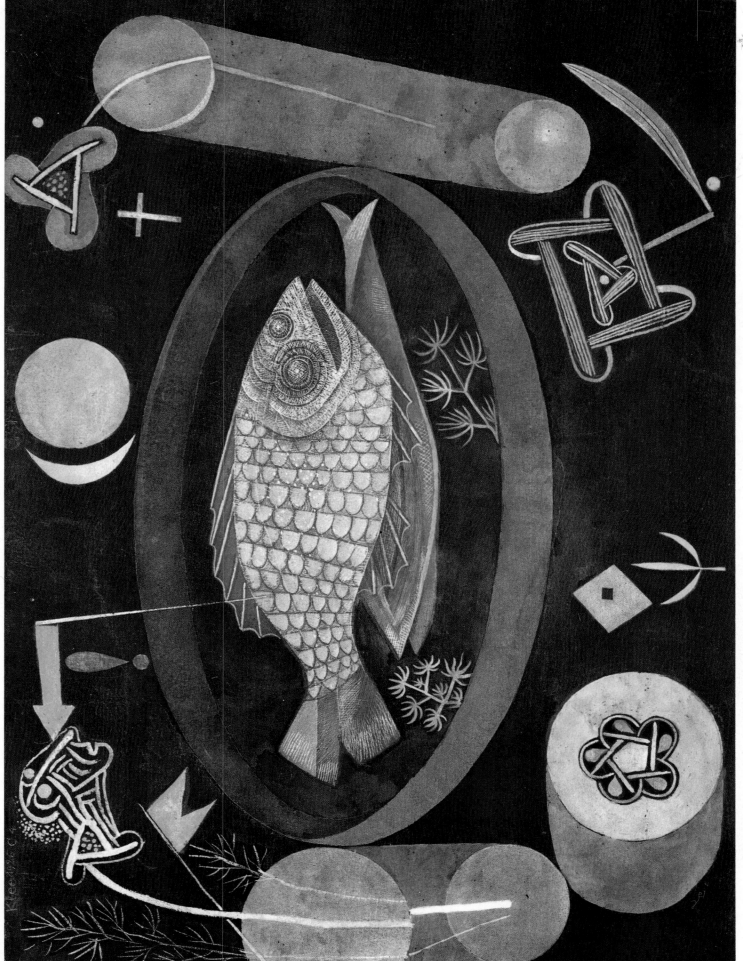

21. *Around the Fish.* 1926. New York, Museum of Modern Art

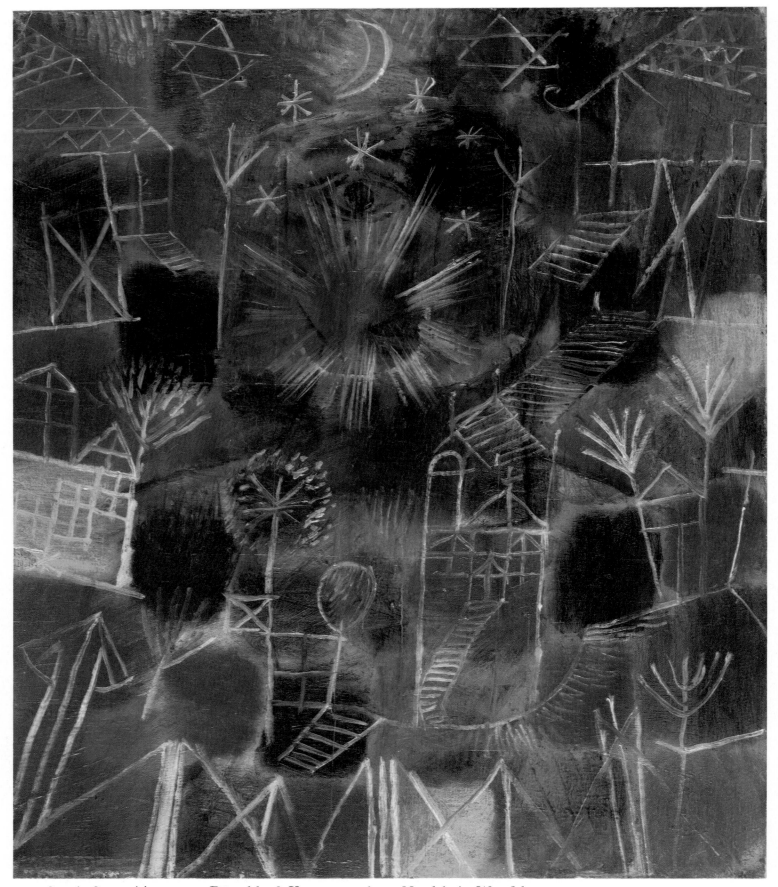

22. *Cosmic Composition*. 1919. Düsseldorf, Kunstsammlung Nordrhein-Westfalen

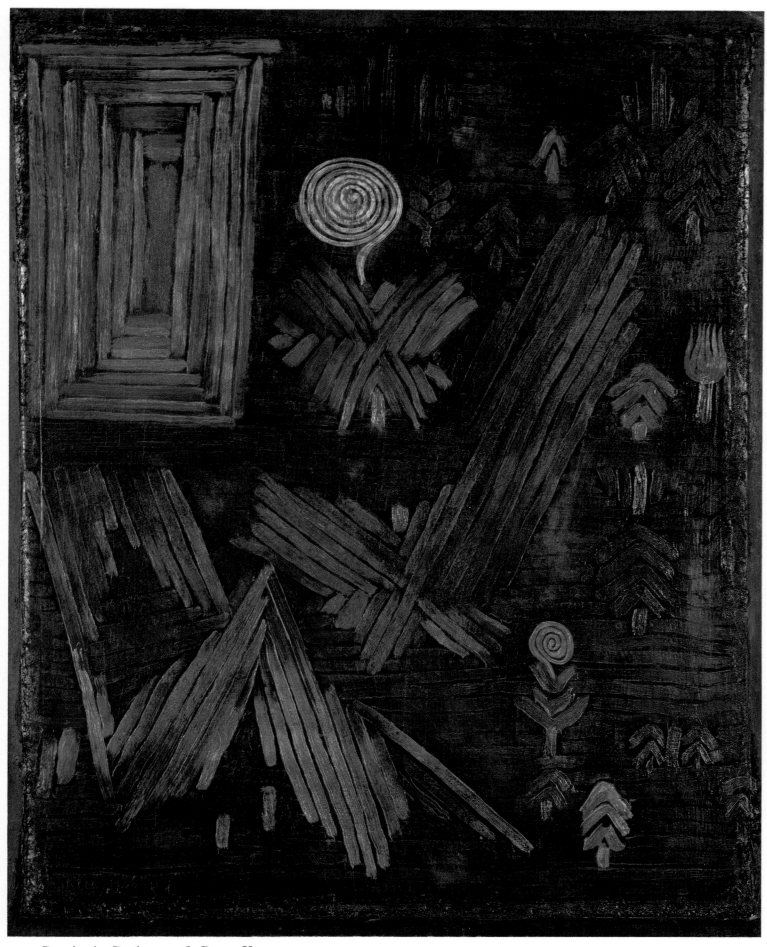

23. *Gate in the Garden.* 1926. Bern, Kunstmuseum

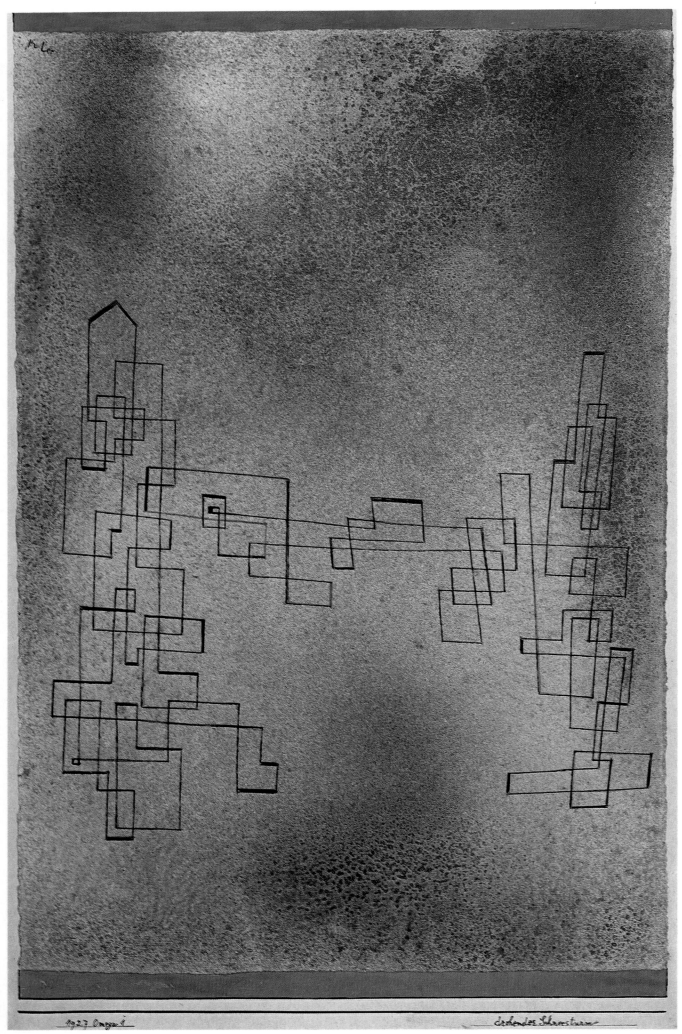

24. *Threatening Snowstorm.* 1927. Edinburgh, Scottish National Gallery of Modern Art

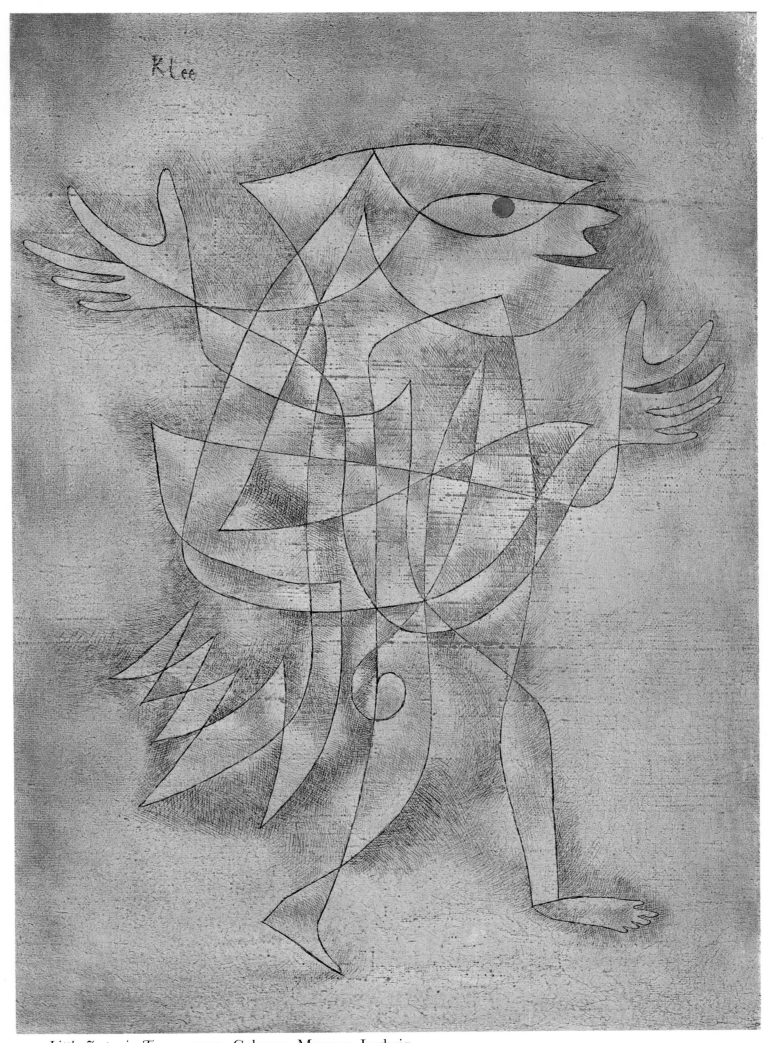

25. *Little Jester in Trance*. 1929. Cologne, Museum Ludwig

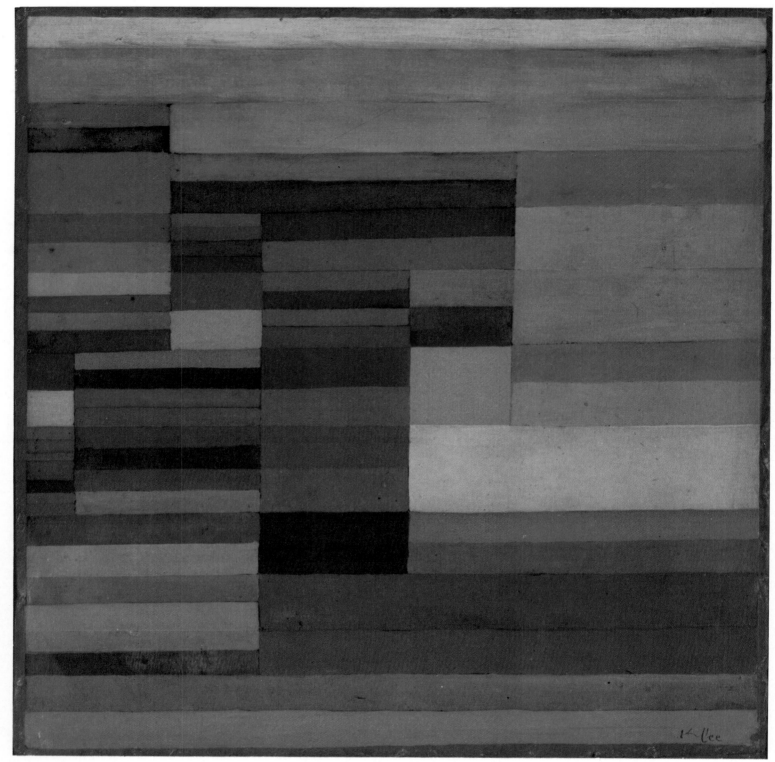

26. *Fire in the Evening*. 1929. New York, Museum of Modern Art

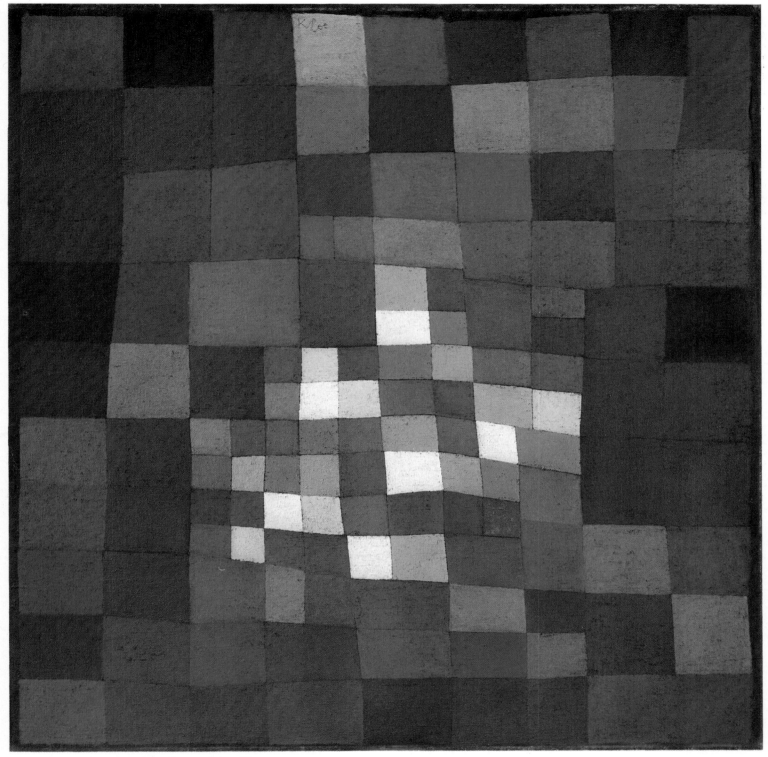

27. *Blossoming*. 1934. Winterthur, Kunstmuseum

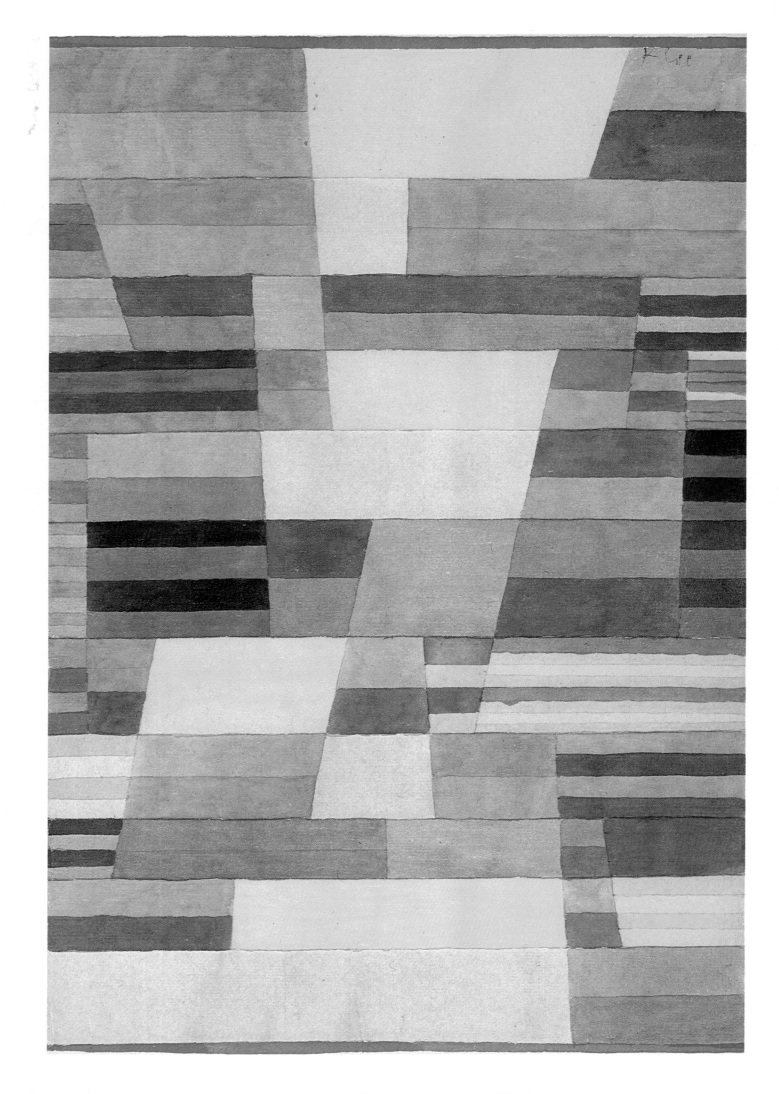

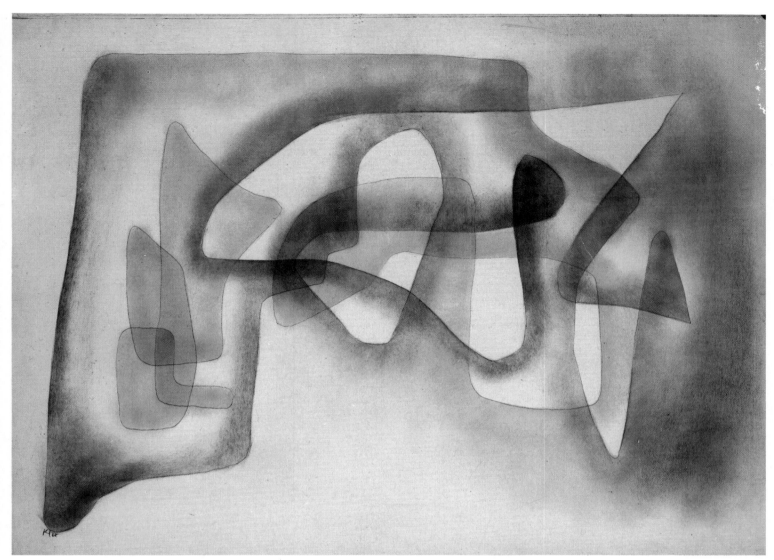

29. *Three Subjects, Polyphony*. 1931. London, Fischer Fine Art Ltd.

28. *Monument in Fertile Country*. 1929. Bern, Klee Foundation

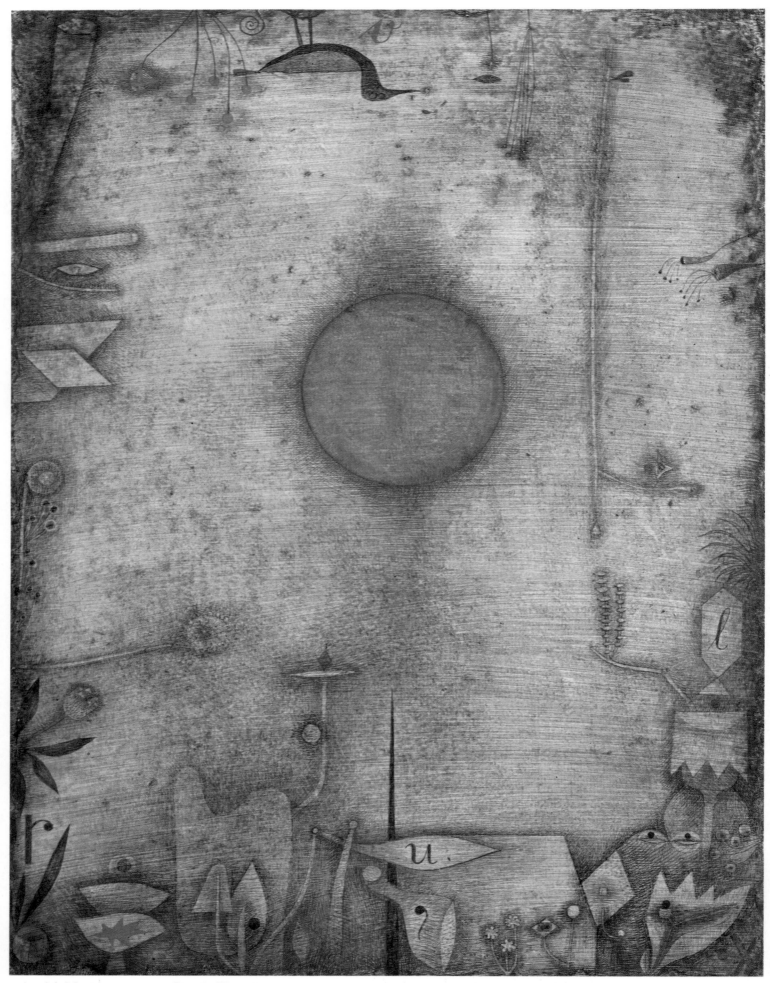

30. *Ad Marginem.* 1930. Basel, Kunstmuseum

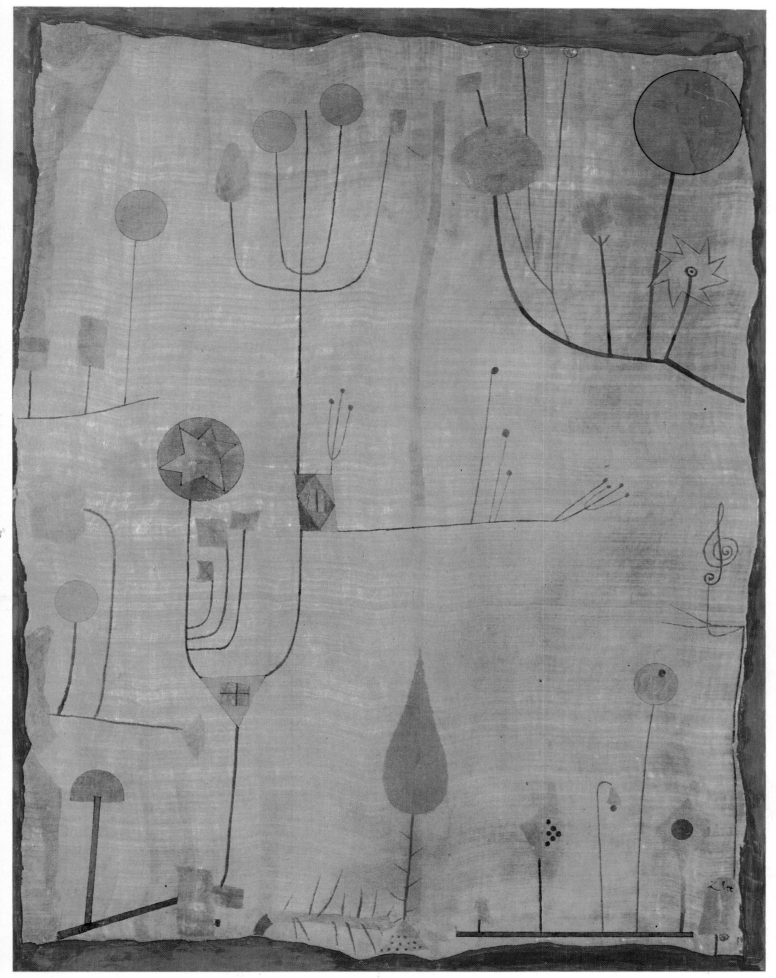

31. *Fruits on Red.* 1930. Munich, Städtische Galerie im Lenbachhaus

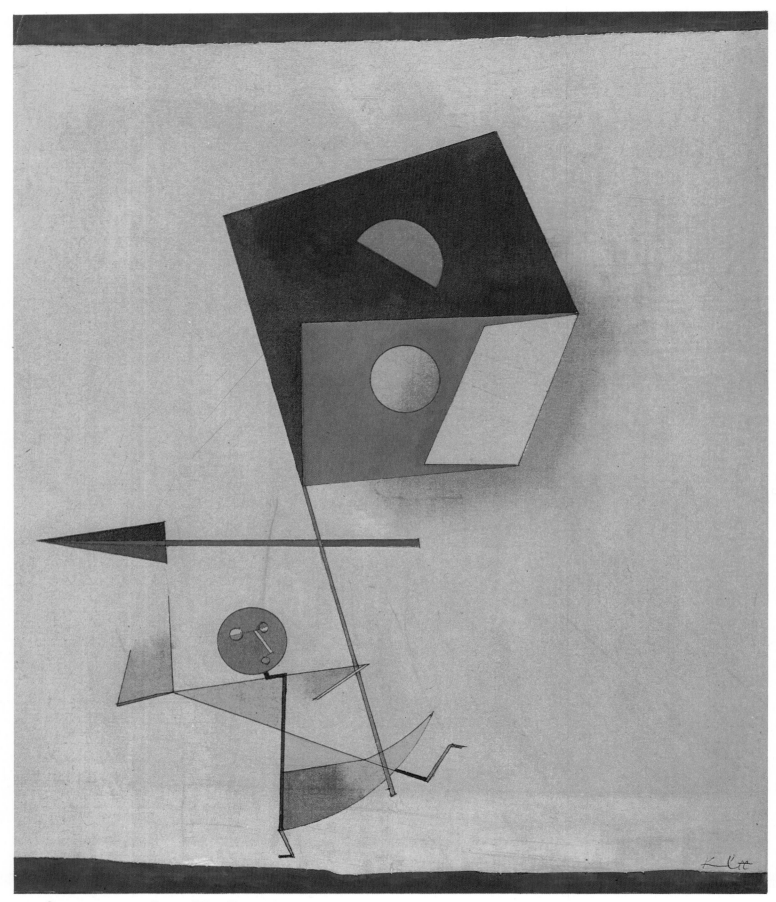

32. *Conqueror*. 1930. Bern, Klee Foundation

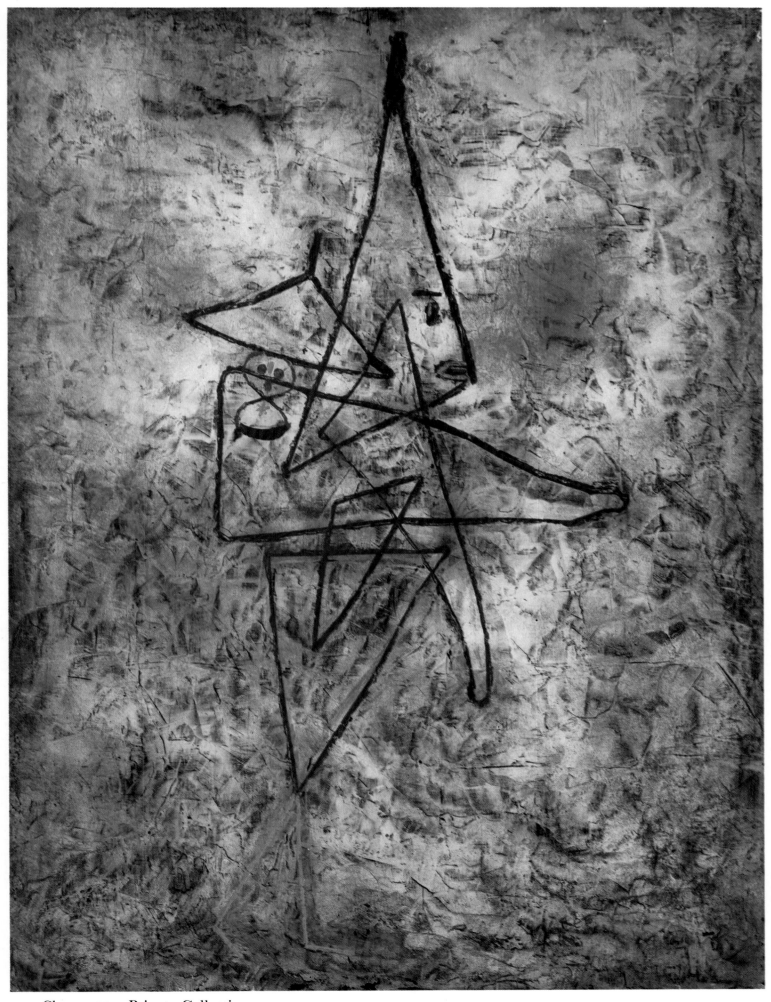

33. *Clown*. 1931. Private Collection

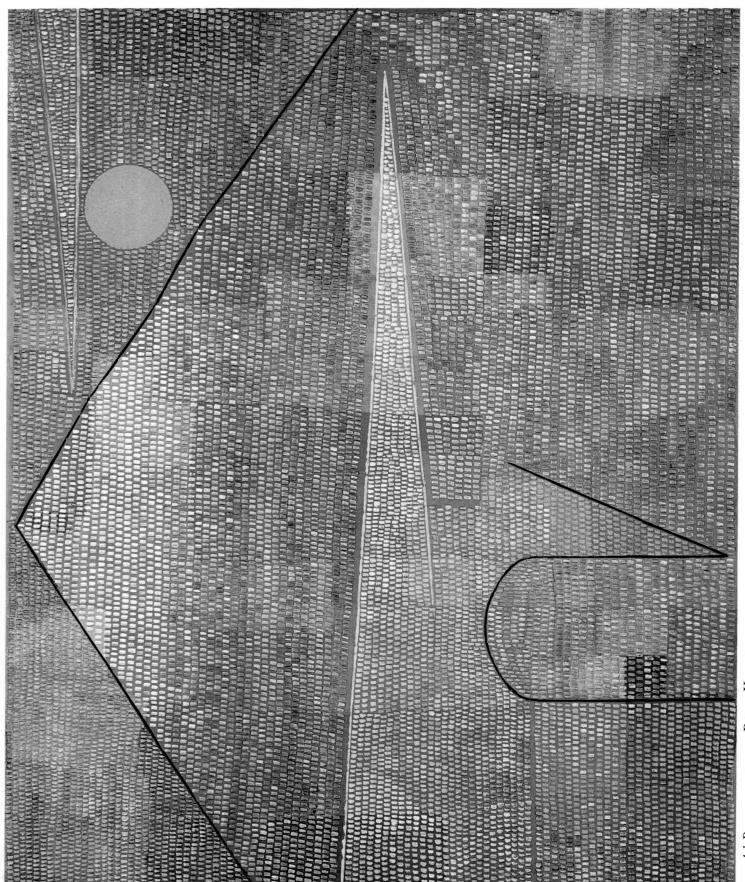

34. *Ad Parnassum.* 1932. Bern, Kunstmuseum

35. *Polyphony.* 1932. Basel, Kunstmuseum

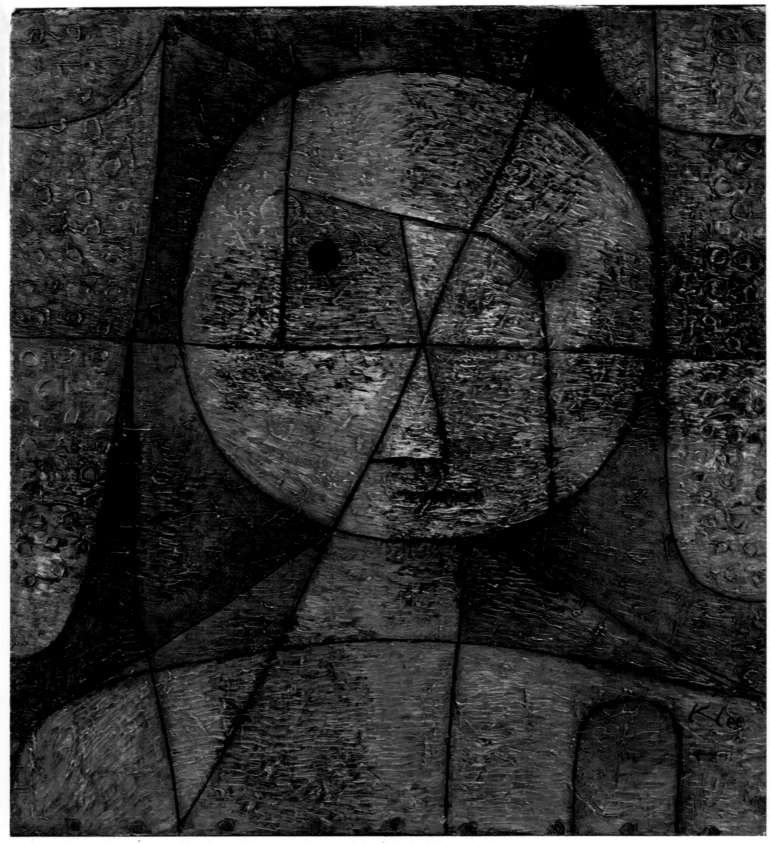

36. *Drawn One.* 1935. Düsseldorf, Kunstsammlung Nordrhein-Westfalen

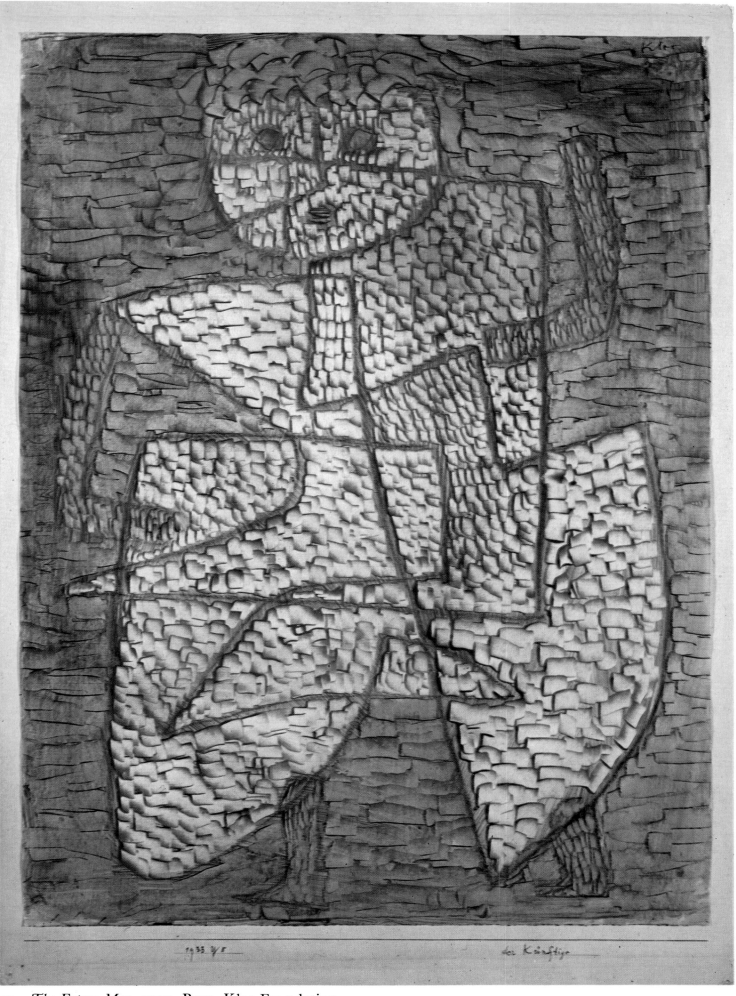

37. *The Future Man.* 1933. Bern, Klee Foundation

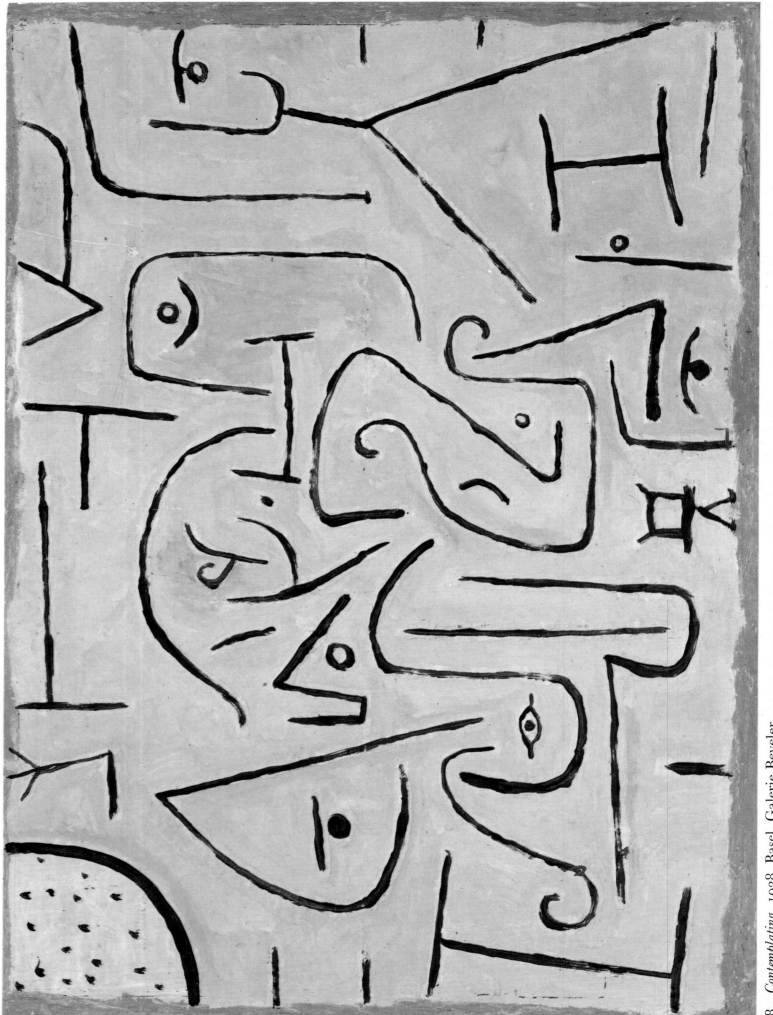

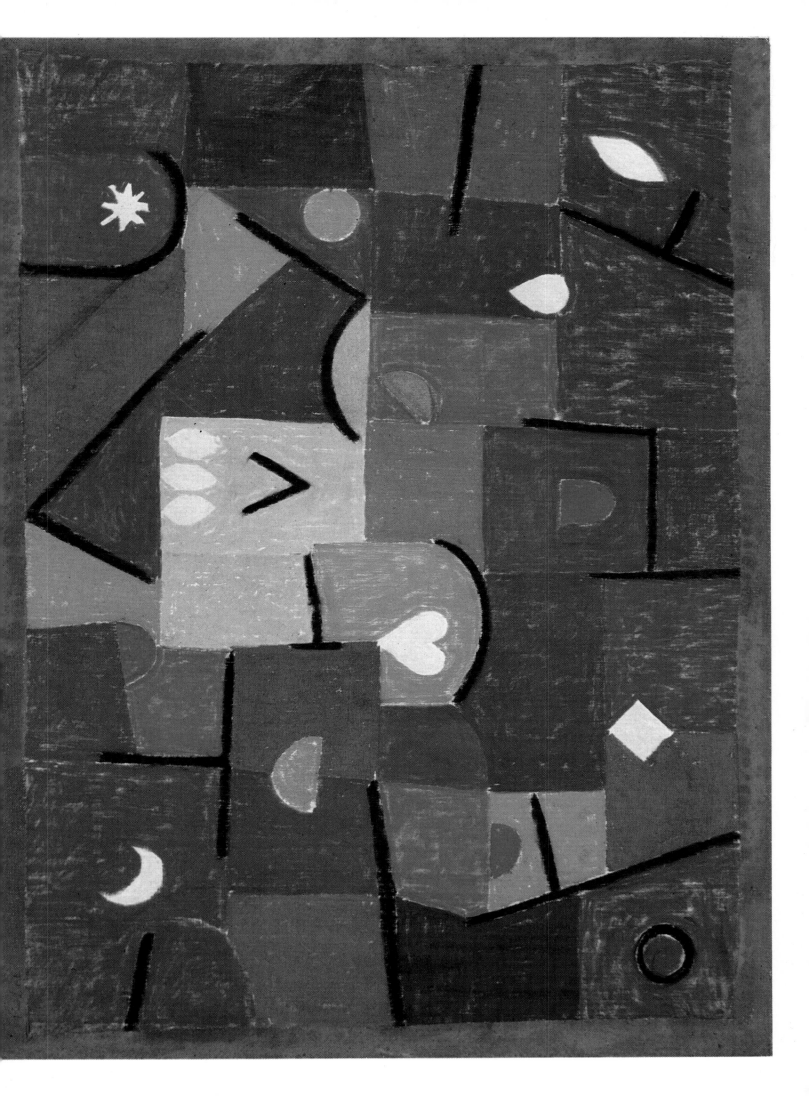

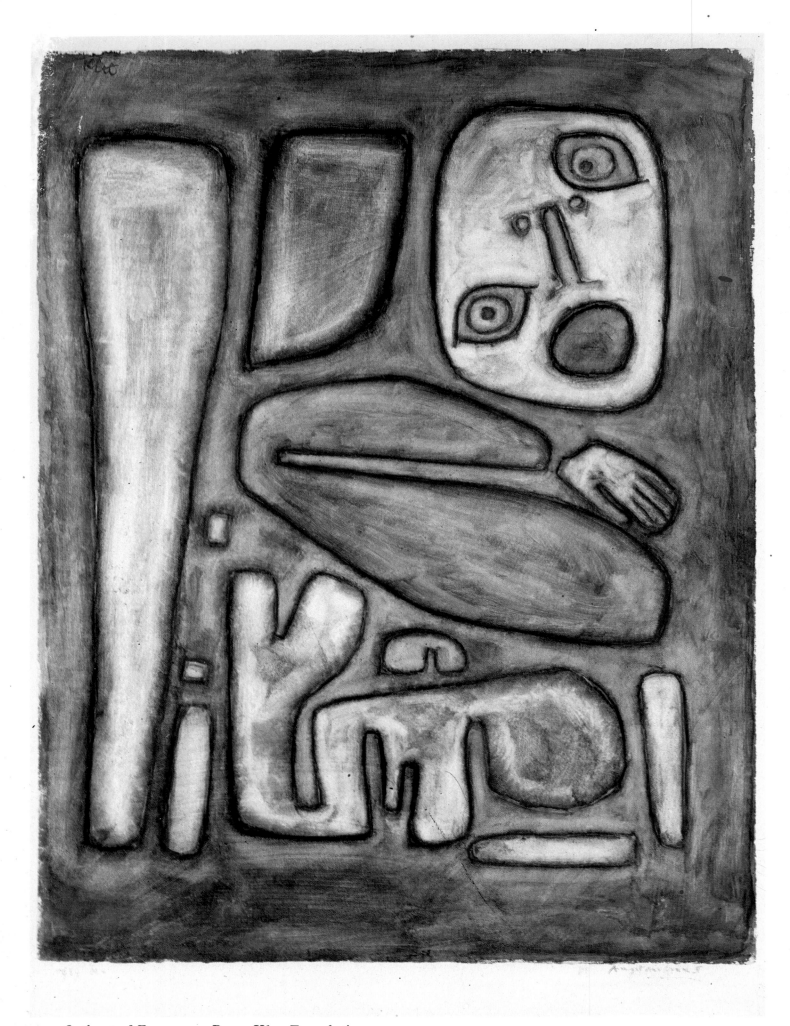

40. *Outburst of Fear*. 1939. Bern, Klee Foundation

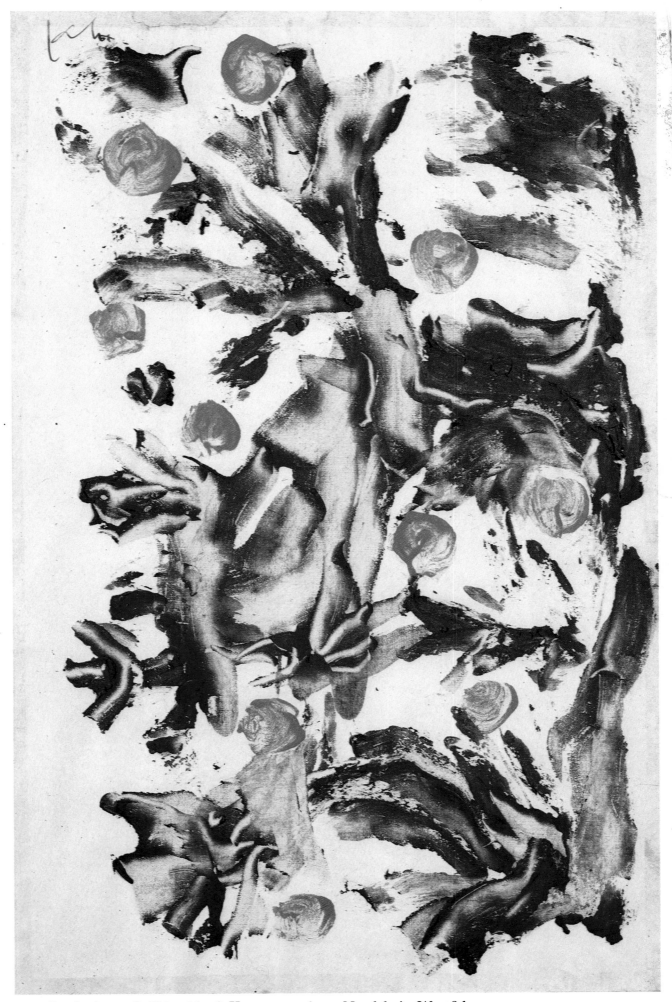

41. *Rosebush*. 1938. Düsseldorf, Kunstsammlung Nordrhein-Westfalen

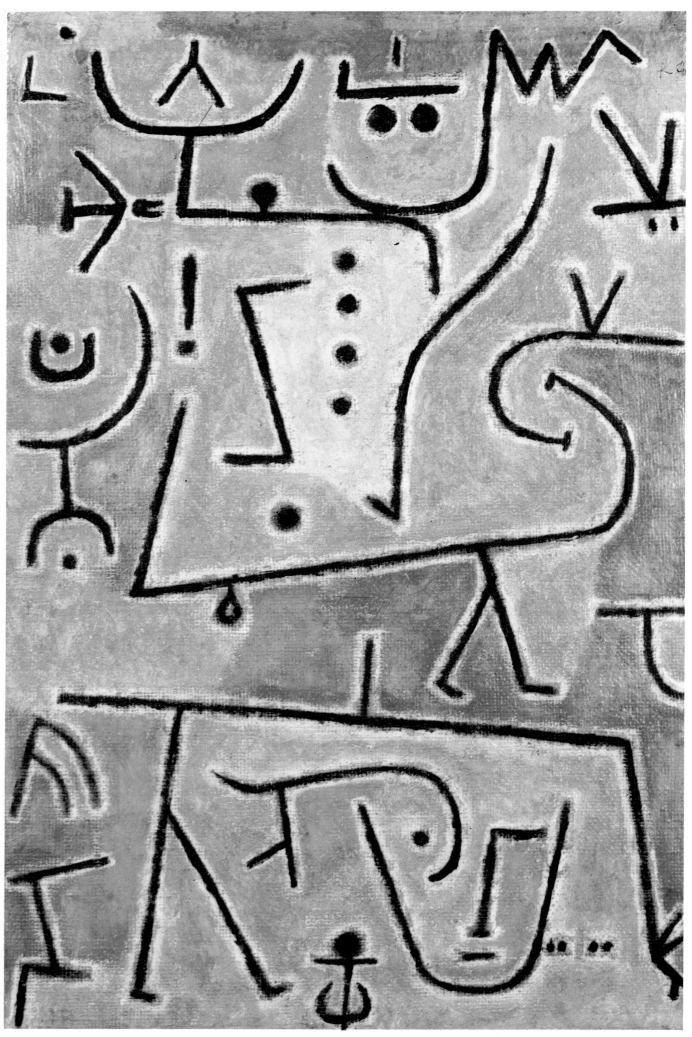

42. *Red Waistcoat*. 1938. Düsseldorf, Kunstsammlung Nordrhein-Westfalen

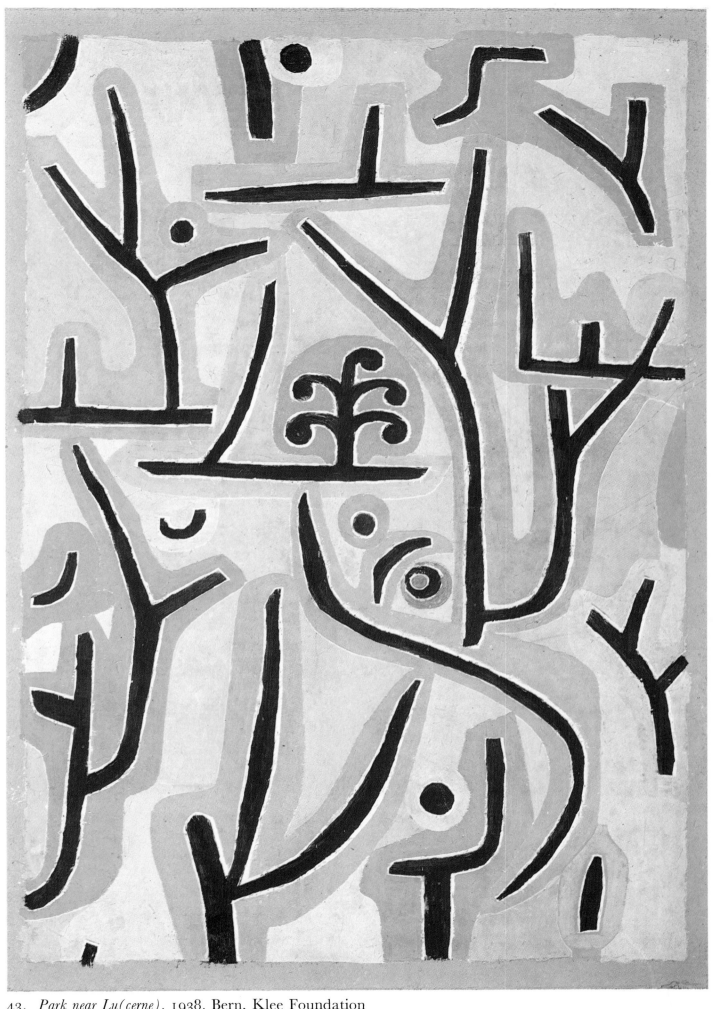

43. *Park near Lu(cerne)*. 1938. Bern, Klee Foundation

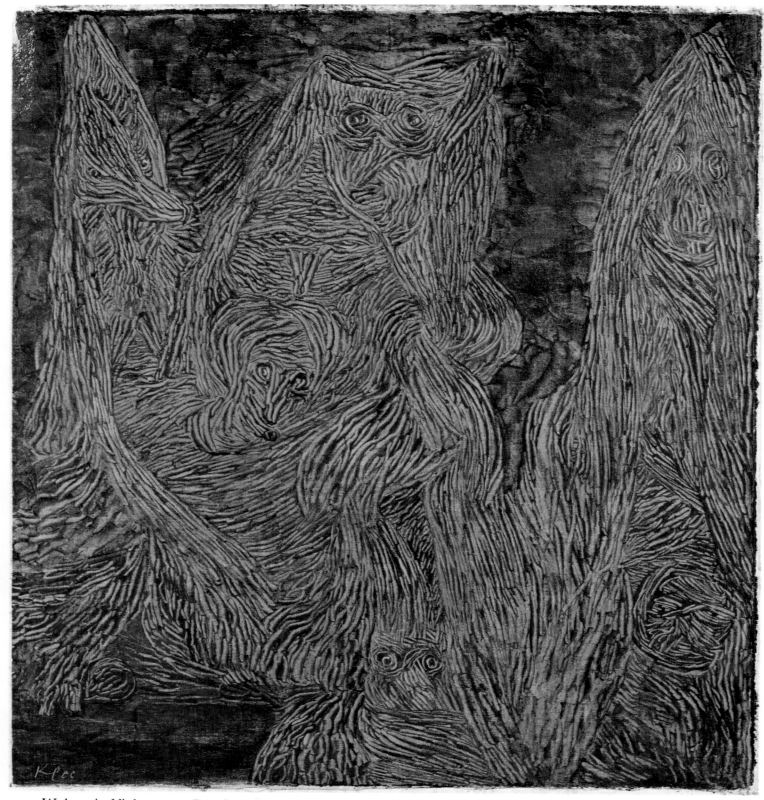

44. *Walpurgis Night.* 1935. London, Tate Gallery

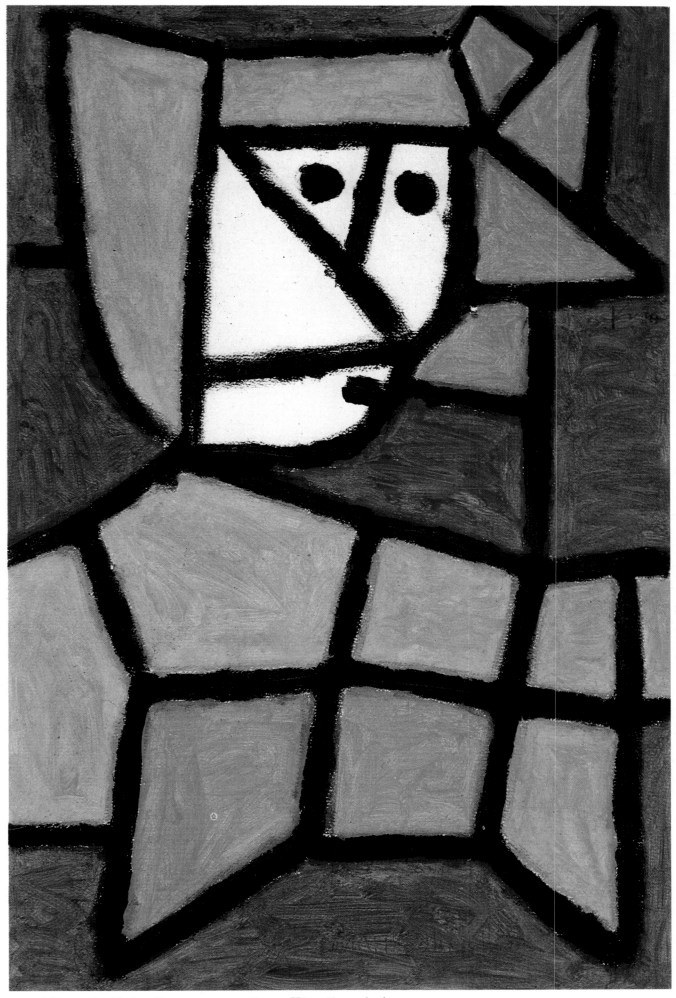

45. *Woman in Native Costume.* 1940. Bern, Klee Foundation

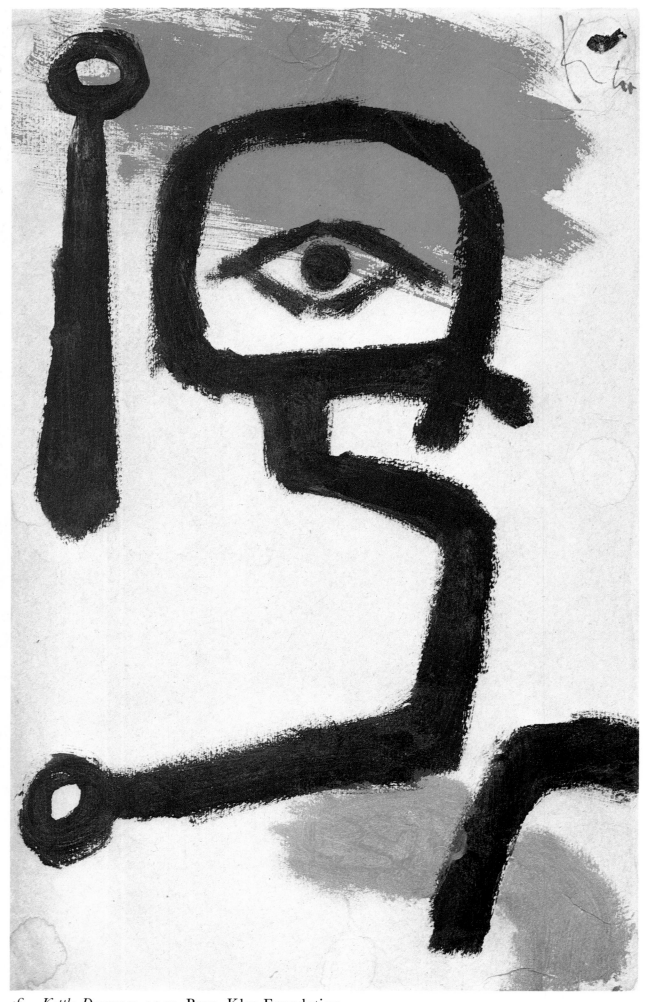

46. *Kettle Drummer.* 1940. Bern, Klee Foundation

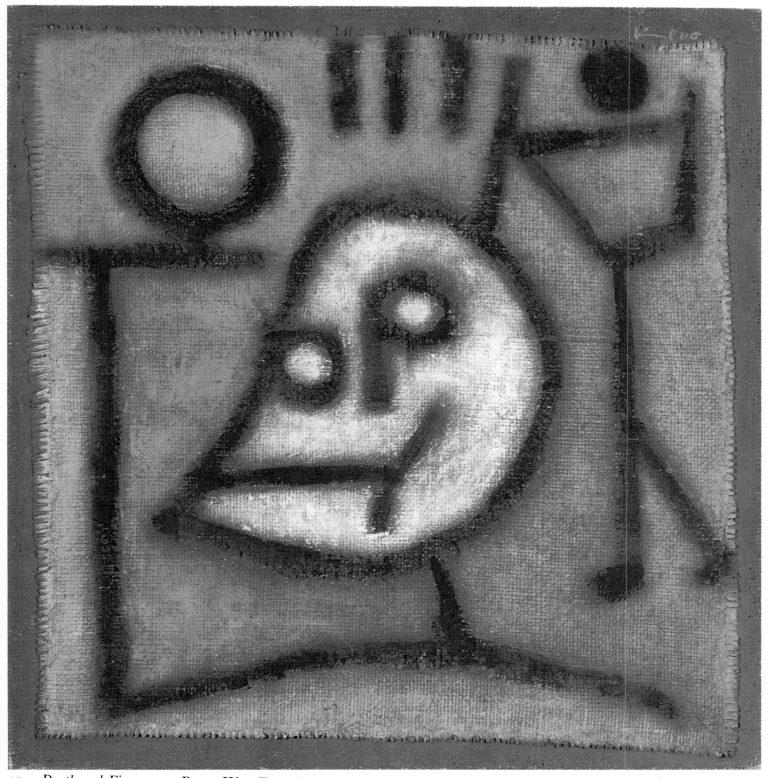

47. *Death and Fire.* 1940. Bern, Klee Foundation

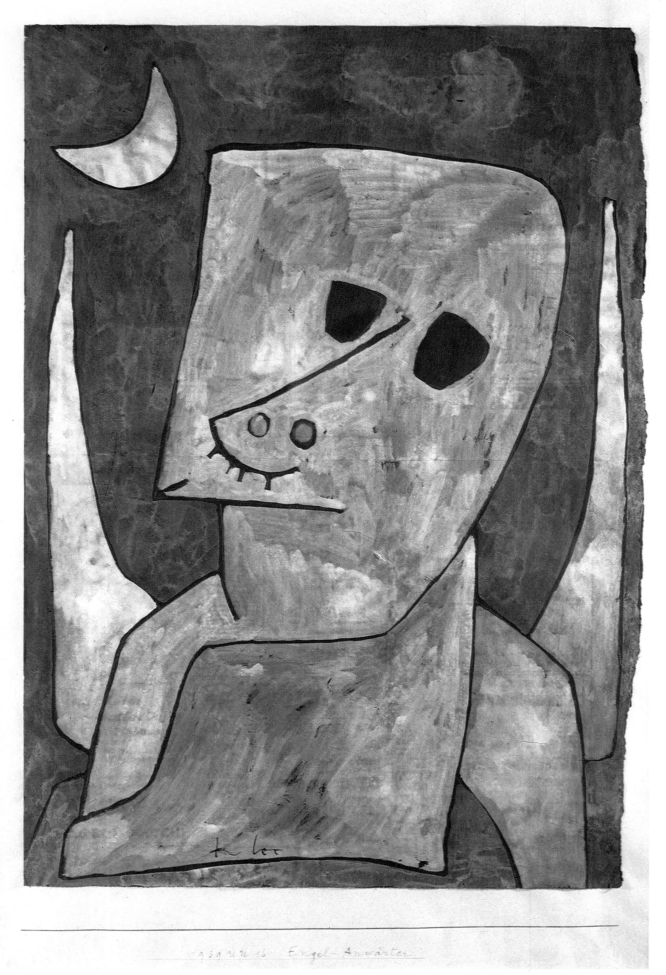

48. *Aspiring Angel.* 1939. Private Collection